CHICAGO CUBS
1926–1940

CHICAGO CUBS
1926–1940

Art Ahrens

Copyright © 2005 by Art Ahrens
ISBN 0-7385-3981-3

Published by Arcadia Publishing
Charleston SC, Chicago IL, Portsmouth NH, San Francisco CA

Printed in the United States of America

Library of Congress Catalog Card Number: 2005929779

For all general information contact Arcadia Publishing at:
Telephone 843-853-2070
Fax 843-853-0044
E-mail sales@arcadiapublishing.com
For customer service and orders:
Toll-Free 1-888-313-2665

Visit us on the Internet at http://www.arcadiapublishing.com

CONTENTS

INTRODUCTION

North-side baseball has not been very successful in the past, oh, 60-odd years. Cubs fans still reeling from the heartbreak of 2003, or who may recall the disastrous end to the 1969 campaign, may be surprised to learn that their "loveable losers" once dominated the National League, and did so with a style and swagger rarely found within the "friendly confines" of more recent years. Between 1926 and 1940, the newly christened Wrigley Field was home to a ball club that put together 14 consecutive winning seasons, claimed 4 league pennants, and fielded future Hall-of-Famers like Hack Wilson, Gabby Hartnett, Kiki Cuyler, Billy Herman, and Dizzy Dean. Sandwiching this tremendous run were pennant-winning seasons during the wartime years of 1918 and 1945. All six World Series appearances ended in defeat; nevertheless, the Chicago Cubs became contenders, year after year, and were setting attendance records long before the simple allure of the nation's most beautiful ballpark was enough in itself to bring out the crowds.

This was also the era in which Wrigley Field became the landmark we all know and love today. The bricks. The ivy. The hand-operated scoreboard, giant clock, and irreplaceable outfield bleachers; all born in the mind of Cubs executive Bill Veeck Jr. Veeck got his start by peddling soda-pop as an 11-year-old boy in the stands of what was then called Cubs Park. In 1927, Wrigley Field became the first National League ball park to break the one million attendance mark, and remained above it for several seasons until the worst years of the Great Depression set in. And those who attended baseball games on Chicago's North Side during this era witnessed some of the great moments in the annals of the game, including Babe Ruth's "called shot" during the 1932 World Series, Gabby Hartnett's "homer in the gloamin'" during an intense 1938 pennant race, and Hack Wilson's 191-RBI season in 1930, still a major-league record.

Four charismatic figures guided the Cubs from 1926 through 1940, all baseball legends in their own right. In 1926, Joe McCarthy, who had never been a player in the majors, took the reigns of a struggling Cubs squad that spent as much time in speakeasies as the practice field, straightened them out, and created a ball club to be reckoned with. He was succeeded by three players-turned-managers: Rogers Hornsby (1930–1932), Charlie Grimm (1932–1938), and Gabby Hartnett (1938–1940). At odds, in turn, with either the ownership, the fans, or in the clubhouse, none lasted all too long at the helm. What did remain constant, however, was the often-stellar plays displayed on the field. All but Grimm eventually wound up in Cooperstown, and many feel that he belongs.

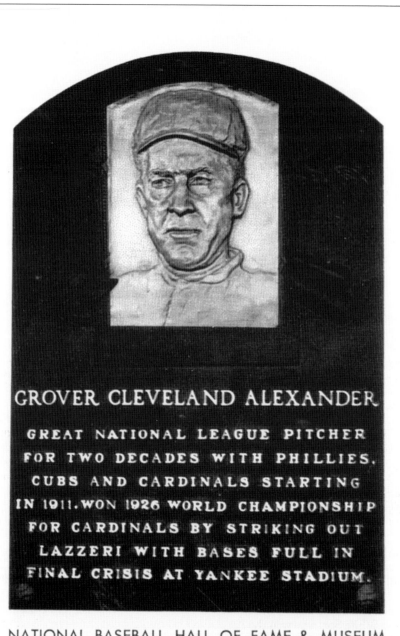

GROVER CLEVELAND ALEXANDER

GREAT NATIONAL LEAGUE PITCHER
FOR TWO DECADES WITH PHILLIES,
CUBS AND CARDINALS STARTING
IN 1911. WON 1926 WORLD CHAMPIONSHIP
FOR CARDINALS BY STRIKING OUT
LAZZERI WITH BASES FULL IN
FINAL CRISIS AT YANKEE STADIUM.

NATIONAL BASEBALL HALL OF FAME & MUSEUM
Cooperstown, New York

This Hall of Fame plaque for Phillies-Cubs-Cardinals great Grover Cleveland Alexander was dedicated at Cooperstown in 1938. His 373 lifetime victories between 1911 and 1930 are tied with Christy Mathewson for the National League record. Alexander had many fine seasons with the Chicago Cubs between 1918 and 1926.

Prologue
The Pre-McCarthy Era
Roaring Twenties

The year was 1919. The last American troops were returning home from the "war to end all wars" while the entire world was reeling from the effects of the Spanish influenza, which took the lives of 20 million during the previous fall and winter. Due to the number of dead, it was the worst plague since the Black Death of the 14th century.

And the Cubs were the defending champions of the National League, having won the 1918 pennant only to lose the World Series to the Boston Red Sox in six games. Their home ballpark at Clark and Addison Streets, where they had relocated in 1916, was called Weeghman Park and bore only a faint resemblance to the Wrigley Field of today. The grandstand was a single deck, the bleachers and scoreboard were at ground level, and the far corners of the outfield had chicken-wire fences, which would be gone by 1920.

Among the soldiers coming back from the European front was ace Cubs pitcher Grover Cleveland Alexander. Like so many others, he returned from the war a different man, with physical and emotional scars that would never fully heal. In addition to having been gassed in combat, Alexander also suffered a hearing loss from cannon fire. He became a lifelong alcoholic and developed epilepsy as well.

Nevertheless, he was still a fine pitcher, going 16-11 for the 1919 Cubs. Lefty Jim "Hippo" Vaughn also went 21-14 in 1919, but the duo could not carry the team on their coattails as the Cubs slipped to a disappointing third in the standings. Most of Chicago's headlines that season went to the White Sox, who won the American League pennant but lost the World Series to an inferior Cincinnati Reds team under mysterious circumstances.

The decline of the Cubs continued in 1920 as they skidded to fifth, despite a banner year by Alexander (27-14 with 173 strikeouts and a 1.91 ERA) and 19 wins by Vaughn, whose star was beginning to set. Little else was noteworthy that season, outside of Weeghman Park being rechristened Cubs Park, a name that would remain until 1926. At the close of the season, Fred Mitchell was dismissed after a four-year stay as field manager.

By 1921 chewing-gum magnate William Wrigley had become sole owner of the team, and the Cubs conducted their spring training on family-owned Catalina Island, California, for the first time. This would be their pre-season headquarters (except for the World War II years) until 1952, when the team moved to Mesa, Arizona.

The new season, however, was a disaster. Former Cubs second baseman Johnny Evers, who had previously managed the team in 1913, was rehired as field manager. Grouchy, hot-tempered, and unable to establish rapport with his underlings, Evers was not the man for the job. Jim Vaughn, who made no bones about his dislike for Evers, quit the team in early July and never pitched again in the majors. Barely a month later Evers was gone too, having been fired in favor of catcher Bill Killefer. But it was a case of "too little, too late," as the demoralized team finished in seventh place, 25 games under .500. It was the Cubs' poorest showing in 20 years.

Under Killefer's leadership, the Cubs became fairly respectable over the next several years. The 1922 team was a pleasant surprise, finishing fifth with an 80-74 record and contending through late August. First baseman Oscar Grimes, shortstop Charlie Hollocher, and catcher Bob O'Farrell all had splendid seasons. But the character who really stole the show was rookie left fielder Lawrence "Hack" Miller. The son of German immigrants, Miller had grown up in a slum neighborhood on Chicago's near North Side, which made him a natural local hero. The beer-loving Miller would twist iron bars, uproot small trees, lift cars up by their bumpers, and pound nails with his bare fists. His .352 batting average has yet to be matched by a Cubs freshman.

History was made at Cubs Park on August 25, 1922, as the Cubs outslugged the Phillies 26-23 in the highest-scoring game in major-league annals. At one time the Cubs led 25-6 (thanks to a 10-run second inning and a 14-run fourth) and the Phillies left the bases loaded at the top of the ninth. The batting stars were Miller, who clubbed two three-run homers, and Cliff Heathcote, who went five-for-five with two doubles, five runs scored, and four driven in.

The Cubs' moderately successful brand of baseball continued for the next two seasons as they pulled in to fourth place in 1923 and fifth place in 1924, with ledgers well above .500. Grover Alexander seemed to be mellowing like old wine, posting a 22-12 mark in 1923 as the Cubs' home attendance mark passed 700,000 for the first time. On September 20, 1924, Alexander won the 300th game of his career, turning back the pennant-bound Giants 7-3 in 12 innings, and going the distance at the Polo Grounds.

More importantly, it was at this time that Charles "Gabby" Hartnett became the first string catcher, supplanting the injured Bob O'Farrell, who would be traded to the Cardinals the following May. (The fact that Hartnett was Alexander's favorite receiver did no harm either.) The 1924 City Series, which the White Sox won in six games, was the first Chicago baseball event to be broadcast on radio.

This enjoyable but unexceptional period would come to an abrupt end in 1925, as the Cubs plummeted to last place in a year notable only for the arrival of first baseman Charlie Grimm via a trade with the Pirates. There were three captains attempting to steer the ship: Killefer (33-42 record), shortstop Walter "Rabbit" Maranville (23-30), and finally George Gibson (12-14).

Maranville's term as manager in his only year as a Cub was especially adventurous, as he routinely led the team into speakeasies after a ball game. The hard-drinking, fun-loving "Rabbit" distinguished his brief managerial stint by beating up a cab driver in Brooklyn, New York; dumping water out of a hotel window upon the head of traveling secretary John O. Seys; and running through a Pullman train car anointing the passengers from a spittoon. After the last incident, club president William Veeck Sr. relieved the Rabbit from his managerial duties, which he probably never wanted from the start. Fortunately, with the 1926 arrival of new field manager Joe McCarthy, better days were ahead—and to come sooner than expected.

Fed Mitchell looks somber in his Cubs pinstripes in 1920, his final of four years as the team's manager. His 1918 team was a pennant winner, but the glory was fleeting.

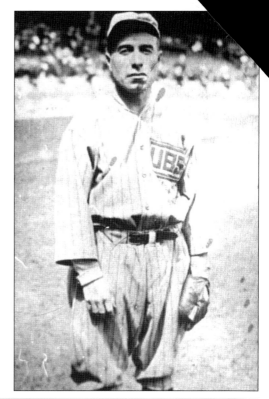

Pictured above is Cub first baseman Charlie Grimes stretching out in the early 1920s. Grimes had two great seasons in 1921 and 1922, batting .321 and .354, respectively. Unfortunately, a herniated disk sustained in mid-1923 led to a premature end of his baseball days. Released by the Cubs in 1924, he attempted a failed comeback with the Phillies two years later.

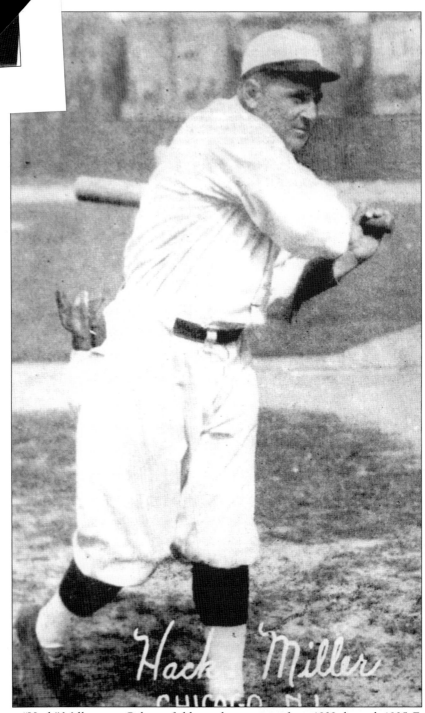

Lawrence "Hack" Miller was a Cubs outfielder and strongman from 1922 through 1925. Following "cups of coffee" with the Dodgers and the Red Sox, Miller had a great rookie year in Chicago in 1922 with a .352 batting average, 12 home runs, and 78 RBIs, while wowing fans and teammates with amazing feats of strength. But Miller was slow and clumsy in the outfield, resulting in an early exit from the major leagues. By May 1925, he was out of the picture, a .323 lifetime hitter.

Tony Kaufman, Cubs pitcher, is seen here in 1922 or 1923. Largely forgotten today, Kaufman had his best year as a Cub in 1924, when he went 16-11. He was a coach for the Cardinals in later years.

When Charlie Hollocher, seen here around 1920, batted .316 as a rookie in 1918, the Cubs thought they were set with a shortstop for years to come. But the moody Hollocher soon began missing lengthy periods with stomach pains that many thought imaginary. After having a career year in 1922 (.340 batting average, 201 hits), he appeared in less than half of the games in both of the following two seasons. His abbreviated stay in Chicago ended in 1924 with a .304 lifetime average and 894 hits, and one can only speculate on the career that might have been. Hollocher committed suicide in 1940.

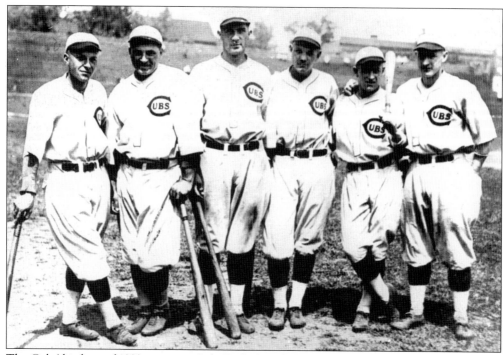

The Cubs' big bats of 1922 posing at Cubs Park, from left to right, are Charlie Hollocher (.340), Hack Miller (.352), Oscar Grimes (.354), Barney Friberg (.311), Arnold Statz (.297), and Bob O'Farrell (.324). The 1922 Cubs hit .293 as a team but finished only fifth with an 80-74 record. Beyond Grover Alexander and Vic Aldridge, both of whom won 16 games, they had little in the way of quality pitching.

Arnold Statz, Cubs outfielder, is seen here sometime between 1922 and 1925. Statz enjoyed his best season in 1923, when he batted .319 with 209 hits and 110 runs scored. He later became a consultant in Hollywood for baseball-oriented movies

Hall of Fame shortstop Walter "Rabbit" Maranville poses during batting practice in 1925, his only year as a Cub. His brief stay in Chicago was not successful, either as a player or a manager.

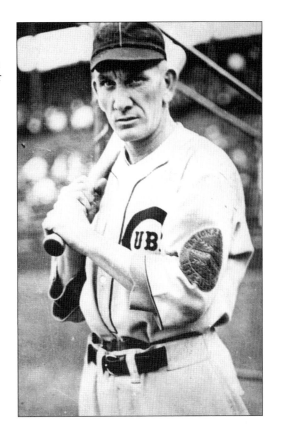

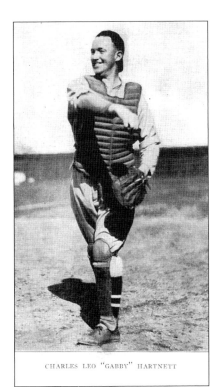

CHARLES LEO "GABBY" HARTNETT

A young Gabby Hartnett warms up in 1925. Although his best years were still ahead of him at this point, Hartnett was showing early signs of superstardom.

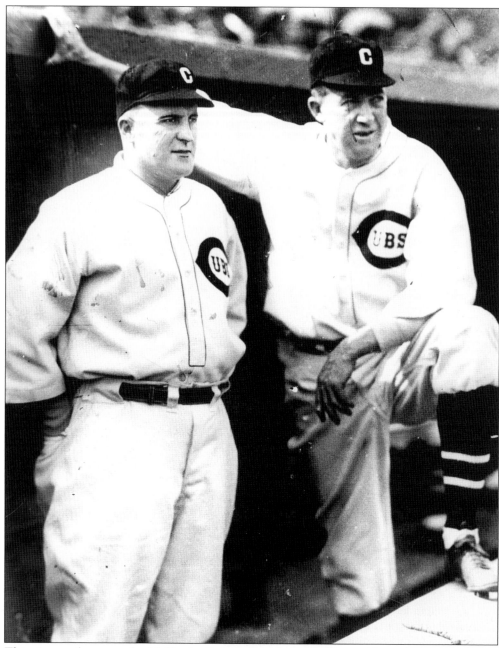

This picture of manager Joe McCarthy (left) and pitching ace Grover Alexander in early 1926 is a rarity because Alexander did not last long as a Cub after McCarthy took the reigns. Alexander was suspended in mid-June for violating training regulations (getting drunk six times in 10 days) and a week later was waived to the Cardinals. He won 9 of 12 decisions for St. Louis, helping them win the 1926 flag and the World Series.

ONE

Joe McCarthy Builds a Winner

1926–1930

The great Cubs turnaround, which would eventually lead to winning pennants, began on October 13, 1925, when "Marse" Joe McCarthy was hired as manager. Although he had never played in the majors, McCarthy had been a successful field leader in the minor leagues, winning several flags with Louisville of the American Association. In inheriting an anarchic team that had just finished last, McCarthy had his work cut out for him—and he knew it. He saw a good nucleus in the likes of Gabby Hartnett, Charlie Grimm, infielder Sparky Adams, and pitcher Guy Bush, but he also realized that additions were necessary.

McCarthy's first move was to inform team president William Veeck Sr. about Lewis "Hack" Wilson, whom the Giants had left unprotected in their farm chain. The Cubs drafted Wilson, and for the next five years he set Chicago on fire with his home-run bat and after-hours escapades. If any one player epitomized Prohibition-era Cubs baseball, it was mighty Hack.

In the park that had been renamed Wrigley Field, the new order was officially inaugurated on May 23, 1926, when Wilson became the first player to homer off the center-field scoreboard (still on ground level) in the fifth inning as the Cubs scalped the Braves 14-8. Sparky Adams collected four hits, and fans threw pop bottles at umpire Jim Sweeney for ejecting Cub third-baseman Howie Freigau from the game. That night, Hack and several companions were arrested at a friend's apartment for drinking beer in violation of the Volstead Act. It was preview of coming attractions as the 1920s finally began to roar in earnest.

Other 1926 newcomers who paid immediate dividends were pitcher Charlie Root (18 wins, 2.82 ERA) and outfielder Reggie Stephenson, who batted .338 in 82 games after coming up from Indianapolis in June. Gabby Hartnett came into full bloom under McCarthy's tutelage, while Guy Bush began to look like a major-league pitcher. The Cubs ended the season a strong fourth, only seven games behind the pennant-winning Cardinals.

But the road to success had its price. To solidify his authority over his players, McCarthy quickly came into conflict with alcoholic pitching ace Grover Alexander. Alex had had things largely

his own way under previous managers and was looked upon as the unofficial team leader by the younger players. McCarthy laid down training rules; Alexander defied them—repeatedly—and ended up getting waived to the Cardinals in June 1926. From that point on, everyone knew who was in charge.

The future looked even brighter as the 1927 season unfolded. Three of the most memorable dates in the team's chronicles occurred in May of that year. On May 14, Guy Bush went the distance—18 innings—to beat the Braves at Boston 7-2. Three days later they edged the same club 4-3 in 22 innings for the longest game, inning-wise, in Cubs annals. In the morning game of a Memorial Day double-header in Pittsburgh, the Pirates had Lloyd Waner on second base and Clyde Barnhart on first. Paul Waner was the batter, and the hit-and-run was on.

With the runners on the move, Cubs shortstop Jimmy Cooney snagged the elder Waner's line drive, stepped on second to double Lloyd, and then tagged Barnhart coming down the line for the only unassisted triple play in Cubs history. Chicago went on to win the game 7-6 in 10 innings. Just nine days after his moment of glory, Cooney was traded to the Phillies for pitcher Hal Carlson. Since the Cubs had 20-year-old Woody English waiting in the wings to assume shortstop duties, the 33-year-old Cooney was an unneeded commodity.

Spurred by a 12-game winning streak in June, the Cubs soared into first place and held that position as late as September 1. However, a 12-18 log during the final month dropped them to fourth place as the Pirates took the flag. In a Wrigley Field that had just been double-decked, the Cubs became the first National League franchise to break one million in attendance—1,163,347 paying customers passed through the home turnstiles.

Despite the September swoon, there was still every reason to be optimistic. Hack Wilson became the first Cub to hit 30 home runs, Riggs Stephenson batted .344, and Charlie Root was the last pitcher on either side of town to win 25 games in a Chicago uniform, going 26-15 that season.

The buoyancy grew more intense on November 28, 1927, when the Cubs traded infielder Sparky Adams and outfielder Floyd Scott to the Pirates for outfielder Hazen "Kiki" Cuyler. While the organization was reluctant to part with the versatile Adams, in dealing away a good journeyman they gained a superstar in return. It proved to be one of the best trades they ever made.

Surprisingly, Cuyler would have an off-season in 1928—at least by his standards. Missing 21 games because of minor injuries and slow to come around at the plate, Kiki batted only .285. Still, his 37 stolen bases led the league while his 17 home runs tied a personal career high. As a defensive outfielder, Cuyler was second to none and his joining the team cemented the Cubs' greatest outfield. Wilson and Stephenson continued to set the batting pace, as Gabby Hartnett crossed the .300 level for the first time. Guy Bush had his best showing to date, going 15-6 to lead the staff in a winning percentage (.714). Rookie Pat Malone was 18-13.

A 13-game winning streak in May gave the Cubs enough momentum to stay in contention the entire season. In a tight battle with the Cardinals and Giants, they pulled in at a threatening third, just four games behind the pennant winning Redbirds. Once again, well over a million patrons payed into the Wrigley Field gates as Chicago's North Side was beginning to catch pennant fever. The Chicago Cubs appeared to be one player away from a championship.

William Wrigley then loosened up his purse strings, shelling out $200,000 plus five run-of-the-mill players to the Boston Braves for batting champ Rogers "Rajah" Hornsby. "The Rajah" had already left his best years behind him in St. Louis but he still swung a dangerous bat. This proved to be the final piece of the puzzle, as the lineup of Hornsby, Cuyler, Wilson, Stephenson, Grimm, and English gave the Cubs their most fearsome Murderers' Row of all time. The 1929 Cubs batted .303 as a team with 140 home runs and 982 runs scored.

The Cubs moved into first place with a 9-5 triumph over the Cardinals on June 28, and they never looked back. They finished 98-54, 10 and a half games ahead of the second-place Pirates, and drew 1,485,166 home fans, a record that lasted for 40 years. It was a year in which everything went right—except for the World Series.

The Cubs opponents were Connie Mack's Philadelphia Athletics, who boasted a formidable "Murderers' Row" of their own with the likes of Al Simmons, Jimmy Foxx, Mickey Cochrane, and Jimmy Dykes, along with pitching aces Lefty Grove, George Earnshaw, and Rube Walberg. The teams appeared to be evenly matched and a seven-game series was anticipated.

Instead, the A's rolled over the Cubs in five games. The stage was set from the first game when 37-year-old Howard Ehmke, a surprise starter, fanned a then World Series record 13 Cubs in a 3-1 win at Wrigley Field. It was a bad omen of what was to follow.

Following a 9-3 drubbing in game two, the Series moved to Philadelphia. Guy Bush breathed some life into the Cubs with a 3-1 victory in game three. Late in the fourth contest, Chicago was poised to tie the series at two games apiece, with the advantage of two of the last three games to be played at Wrigley Field. Pitcher Charlie Root and the Cubs went into the bottom of the seventh inning with a seemingly comfortable 8-0 lead.

Then came the ultimate humiliation. Root suddenly lost his effectiveness as the A's began hitting him at will. McCarthy rushed in four pitchers, none of whom provided any relief. To make matters worse, Hack Wilson lost two fly balls in the sun. By the time the carnage ended, Philadelphia had scored 10 times in the inning en route to a 10-8 victory. They mopped up on the shell-shocked Chicagoans the following day, winning 3-2 to take the series. The Cubs returned home stunned and sullen.

It was also a signal that Joe McCarthy's days as Cubs manager were numbered. McCarthy could hardly be blamed for the team's inability to hit Howard Ehmke, Root's inexplicable collapse, or Wilson's losing battle with the glaring sun. Nevertheless, he began to fall from grace with Wrigley and Veeck.

In spite of the World Series disaster, the Cubs opened the 1930 season confident that they could repeat as pennant winners. The high hopes were dashed at least partially when Rogers Hornsby fractured an ankle sliding into base early in the season. He appeared in only 42 games and would never again be an everyday player.

If 1929 had been the year of Hornsby, 1930 marked the pinnacle for Hack Wilson, whose .356 average, 56 home runs, and 190 RBIs made him the toast of Chicago. Gabby Hartnett, in one of the most spectacular comebacks ever witnessed, came through with the finest season of his career as well, batting .339 with 37 circuit blasts and 122 RBIs. Stephenson hit a career high .367, Cuyler .355, and English .335. As a team, the Cubs batted .309 with 998 runs scored—both 20th-century highs. Their 171 home runs remained a National League record until broken by the New York Giants in 1947. Riggs Stephenson, when asked why he had only driven home 68 runs, replied, "I batted behind Wilson, and he didn't leave any batters on base for me to drive in."

Although it was an exciting campaign, the Cubs' heavy hitting could not keep them on top of the league. An uninjured Hornsby probably would have provided the edge. On September 23, 1930, Joe McCarthy was fired as manager and replaced by Hornsby in a case of poor judgment that would haunt the Cubs for years to come. McCarthy did not even know he had been sacked until he read about it in the newspaper, so his bitterness toward the Cub organization was understandable. The team won the final four games of the season under the Rajah but finished second to the Cardinals, two games out.

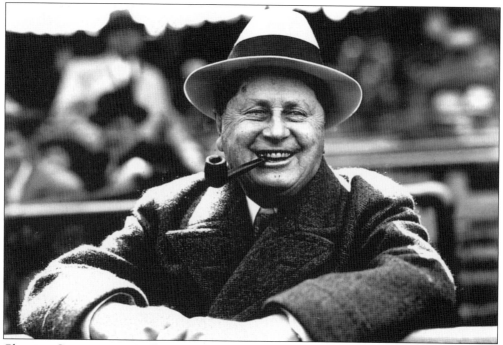

Chewing Gum magnate William Wrigley first invested in the Cubs in 1916. He became the majority stockholder three years later, and was the sole owner of the team by 1921. By his own admission he knew nothing about operating a baseball organization, but he was smart enough to hire someone who did. He appointed sportswriter William Veeck Sr. as club president in 1919. Wrigley died in 1932 and Veeck passed away the following year.

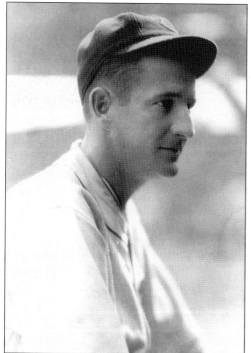

Cliff Heathcote was a fine journeyman outfielder with the Cubs from 1922 through 1930. Originally a Cardinal, Cliff was a good judge of the fly ball and an able base stealer. He had his best year at the plate (as a regular) in 1924, when he hit .309, but by 1927 was strictly a backup man. When the Cubs won the pennant in 1929, Heathcote contributed a .313 average over 82 games. After leaving the Cubs, he played briefly with the Reds and Phillies and called it quits as a .275 lifetime hitter in 1932.

Cubs pitcher Percy Jones is seen here during spring training at Catalina Island. Virtually unremembered today, Jones had a nondescript stint with the Cubs from 1920 through 1922 and again from 1925 through 1928. He did have two fairly good seasons, going 12-7 in 1926 and 10-6 in 1928.

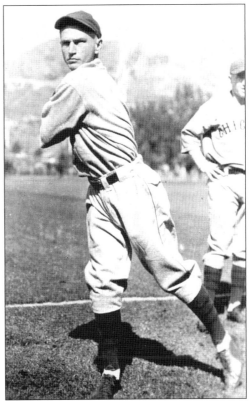

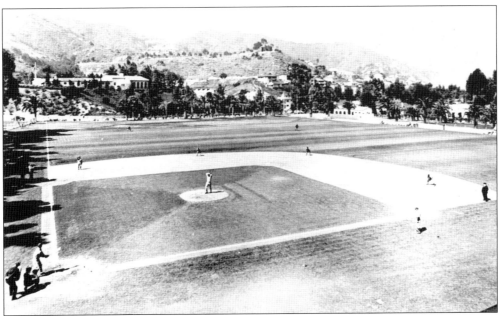

Pictured here is an undated photograph of the baseball diamond on Catalina Island, California, where the Cubs held spring training from 1921 through 1951 (excluding 1943, 1944 and 1945), when they trained at French Lick, Indiana due to wartime travel restrictions. Cubs owner William Wrigley owned the entire island.

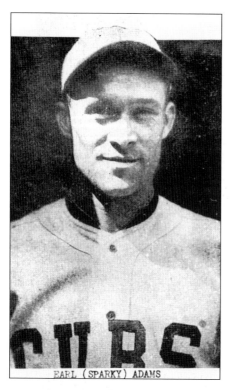

EARL (SPARKY) ADAMS

Earl "Sparky" Adams was a fine infielder for the Cubs from 1922 through 1927, and proved to be equally graceful at second base, shortstop, and third. His best season as a Cub came in 1926 when he batted .309 with 193 hits and 27 stolen bases. As leadoff hitter, he led the league in at-bats in 1925, 1926, and 1927, but was traded along with Floyd Scott to the Pirates for Kiki Cuyler at the end of the 1927 campaign. He helped win two pennants with the Cardinals in 1930 and 1931 (winning the World Series the latter year), before retiring with the Reds in 1934 as a lifetime .286 hitter.

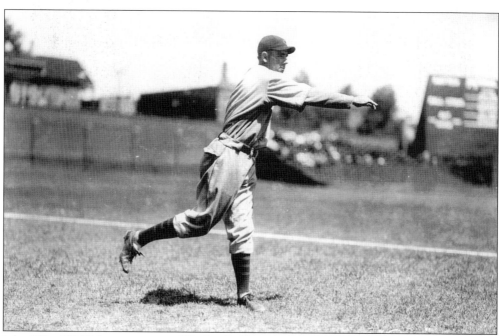

John "Sheriff" Blake warms up at Wrigley Field in this image. A Cub from 1924 through 1931, Blake had an impressive year in 1928 when he went 17-11 with a 2.47 ERA, but was otherwise just average.

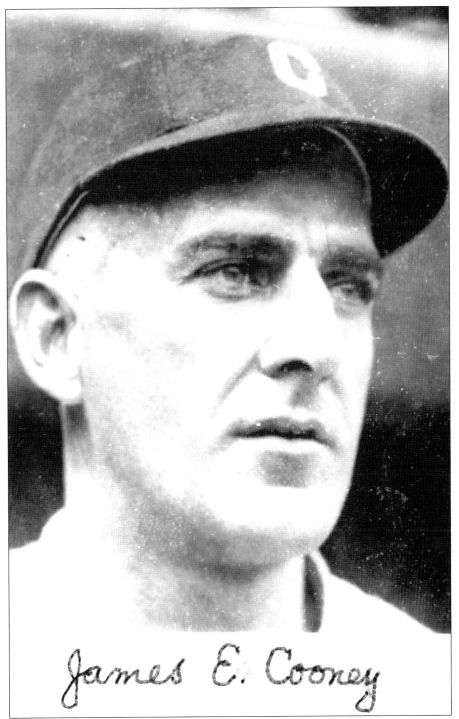

James E. Cooney

Jimmy Cooney was the Cubs' regular shortstop in 1926 and early 1927. On May 30, 1927, in the morning game of a double-header in Pittsburgh, Cooney became the only player in Cubs history to perform an unassisted triple play. Cooney's father, incidentally, had been the Cubs' shortstop from 1890 through 1892.

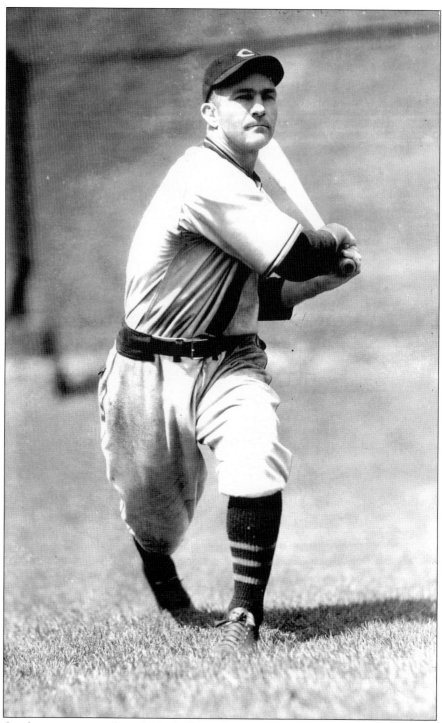

Riggs Stephenson, previously with the Indians, became the Cubs' regular left fielder from June 1926 through 1933, and largely a bench-warmer in 1934, his final season in the big leagues. A .336 lifetime batter with 1,515 hits, Riggs was often hurt and had just five seasons in which he played in 100 or more games. This is likely what has kept him out of the Baseball Hall of Fame.

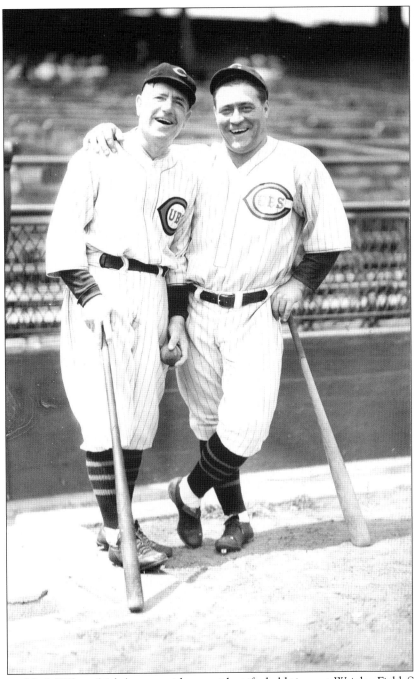

Cub slugger Hack Wilson (right) poses with an unidentified old-timer at Wrigley Field. Signed by the Cubs after the Giants left him unprotected in the draft, Wilson was an immediate sensation in Chicago. For five straight years (1926–1930) he went on one of the most spectacular batting sprees ever witnessed on either side of town, hitting for both power and average. Wilson topped the circuit in home runs four times, RBIs twice, and slugging percentage once, with successive batting averages of .321, .318, .313, .345, and .356. However, as a defensive outfielder he was adequate at best.

Infielder Woody English is pictured during spring training at Catalina Island.

Charlie Root pitched for the Cubs from 1926 through 1941, and still holds the team record for lifetime victories with 201. He won 18 games in 1926, 26 in 1928, and 19 in 1929. But he is best remembered for serving up Babe Ruth's "called shot" home run in the 1932 World Series. To his dying day, Root vehemently denied that Ruth was pointing toward center field.

Pitcher Art Nehf, who enjoyed his best years with the Giants, was in his twilight when the Cubs picked him up in late 1927. He was still good enough to go 13-7 for Chicago in 1928 and 8-5 for the champions in 1929, after which he retired.

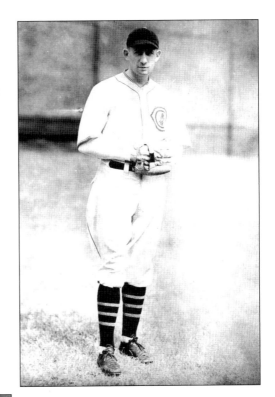

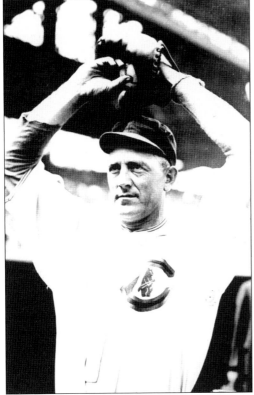

Pitcher Hal Carlson, obtained from the Phillies in June of 1927, went 11-5 for the 1929 flag winners. On May 28, 1930, he died of a stomach hemorrhage in his room at the Carlos Hotel, a short walk from Wrigley Field. A popular player, Hal was sorely missed by his teammates.

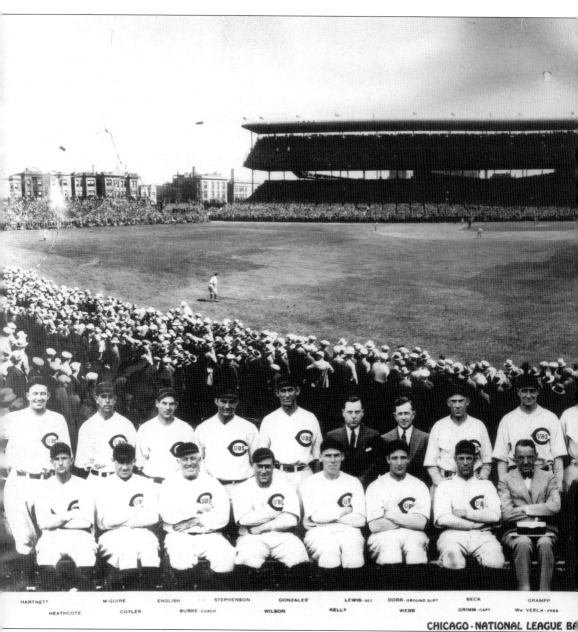

The 1928 Cubs are superimposed over a shot of Wrigley Field during a May game versus the New York Giants. Note that the bleachers were still situated at ground level, and that fans still stood in the outfield at that time. Field crowds were last allowed at the ballpark in 1936, as the

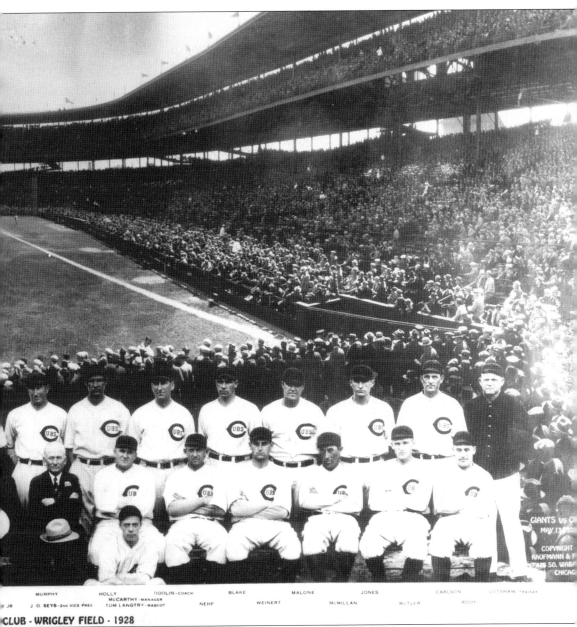

MURPHY HOLLY DOOLIN·COACH BLAKE MALONE JONES CARLSON LOTSHAW·TRAINER

JR J. O. SEYS·2ND VICE PRES. TOM LANGTRY·MASCOT NEHF WEINERT McMILLAN BUTLER ROOT

McCARTHY·MANAGER

GIANTS vs C
MAY 13 19
COPYRIGHT
KAUFMANN & F
25 SO. WAB
CHICAG

CLUB - WRIGLEY FIELD - 1928

bleachers were rebuilt the following season. As for the 1928 Cubs, they were a team on the rise that finished a close third with a 91-63 log, four games behind the pennant-winning Cardinals.

Burly pitcher Pat Malone joined the Cubs as a rookie in 1928, promptly losing his first seven decisions. But Joe McCarthy refused to lose faith in him, and Pat soon turned things around to finish the year at 18-13 with a 2.84 ERA. He followed up with a 22-10 ledger and a league-leading 166 strikeouts in 1929, and 20-9 mark in 1930. Malone never reached those numbers again but was a mainstay in the Cubs rotation through 1934. He spent his final three seasons as a hurler with McCarthy's Yankees and retired in 1937 with a 134-92 career record.

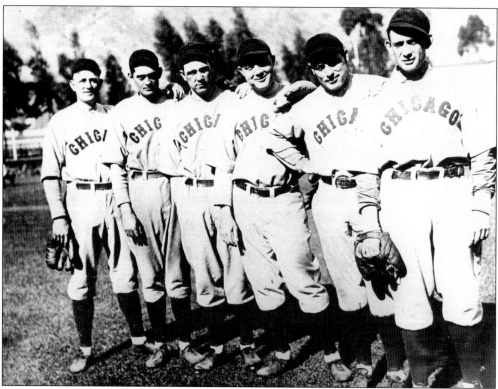

Cubs hurlers line up for a snapshot at Catalina Island in 1928 or 1929. Pictured from left to right are Hal Carlson, Guy Bush, Sheriff Blake, Pat Malone, Charlie Root, and Art Nehf.

Rogers Hornsby put together one of the greatest displays of hitting in Cubs chronicles in 1929 when he batted .380 with 47 doubles, 7 triples, 39 home runs, and 149 RBIs. He also set club records of 229 hits and 156 runs scored. Possibly the best right-handed hitter of all time, The Rajah had his best years with the Cardinals from 1915 through 1926, including a 20th-century high of .424 in 1924. He finished his career as player-manager for the lowly St. Louis Browns in 1937. Hornsby's lifetime batting average of .358 is second only to Ty Cobb's .367. He was named to the Baseball Hall of Fame in 1942.

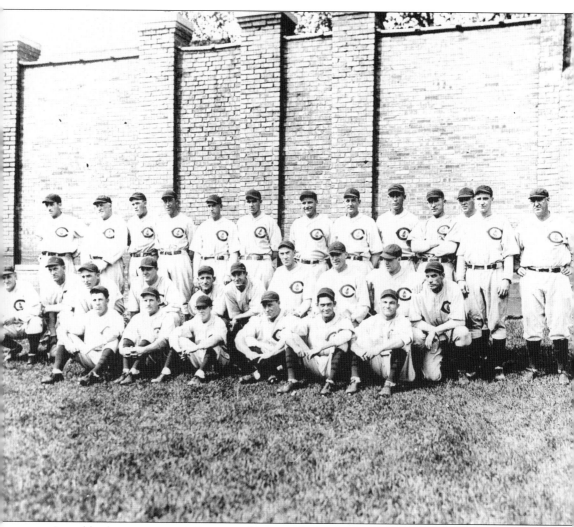

Arguably the most outstanding assemblage in the team's history, the 1929 Cubs won the flag by a 10 and a half game margin over the second-place Pirates. The Cubs batted .303 as a team, scored 982 runs, and socked 140 round trippers. Hornsby hit .380, Riggs Stephenson .362, Kiki Cuyler .360, and Hack Wilson .345. In addition to this were their RBI totals, led by Wilson with a league-leading 159, Hornsby with 149, Stephenson with 110, and Cuyler with 102. Charlie Grimm came close to joining the "100 Club" with 91 RBIs. The top pitchers were Pat Malone (22-10), Charlie Root (19-6), and Guy Bush (18-7), and the staff had the second lowest ERA in the league. The only weakness in the lineup came at the catcher spot, with Gabby Hartnett relegated to the role of pinch hitter with a sore arm. Mike Gonzales and Zack Taylor did most of the receiving, and were adequate but nowhere near the same class as Hartnett. In the World Series, the Philadelphia Athletics clipped the Cubs in five games. Would a healthy Harnett have made the difference?

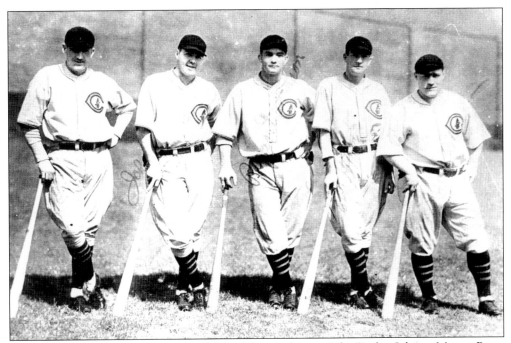

The Cubs outfielders of 1929, pictured from left to right, are Kiki Cuyler, Johnny Moore, Riggs Stephenson, Cliff Healthcote, and Hack Wilson. The regulars were Stephenson in left, Wilson in center, and Cuyler in right. Heathcote was the main backup and Moore little more than a bench warmer.

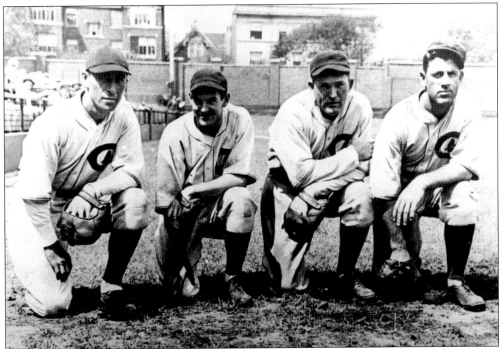

The Cubs starting infielders of 1929, pictured from left to right, are Norm McMillan (third base), Woody English (shortstop), Rogers Hornsby (second base), and Charlie Grimm (first base).

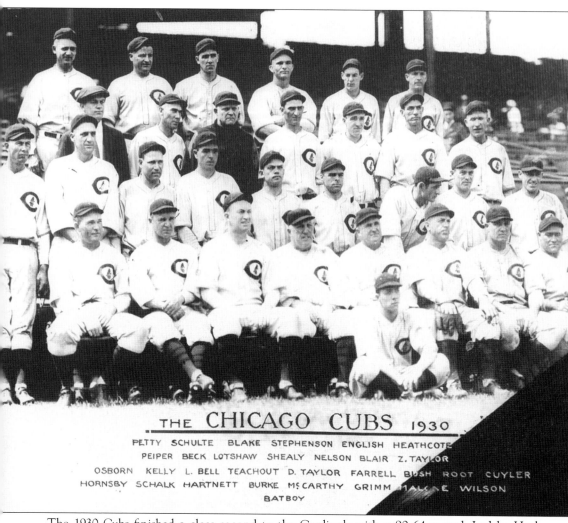

THE **CHICAGO CUBS** 1930

PETTY SCHULTE BLAKE STEPHENSON ENGLISH HEATHCOTE
PEIPER BECK LOTSHAW SHEALY NELSON BLAIR Z. TAYLOR
OSBORN KELLY L. BELL TEACHOUT D. TAYLOR FARRELL BUSH ROOT CUYLER
HORNSBY SCHALK HARTNETT BURKE McCARTHY GRIMM MALONE WILSON
BATBOY

The 1930 Cubs finished a close second to the Cardinals with a 90-64 record. Led by Hack Wilson, they belted a then-record 171 home runs, but Rogers Hornsby's fractured ankle probably cost them the pennant.

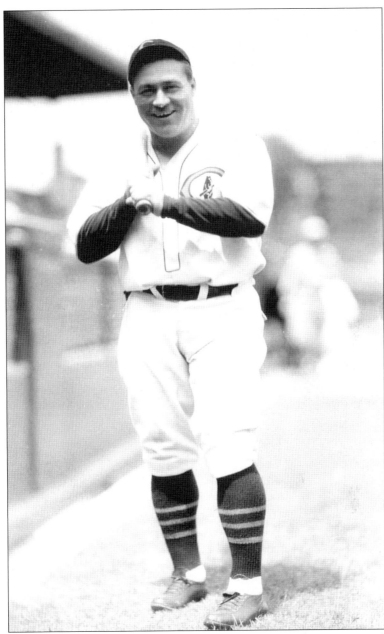

Here is stocky Cubs center fielder Lewis "Hack" Wilson in his record-setting year of 1930, when he hit a then–National League record 56 home runs and a major league record 190 RBIs, which still stands. It was his best and last of five great seasons in a row. Hack's fall was as meteoric as his rise when his output plummeted in 1931 and he was traded to the Cardinals over the winter. St. Louis, in turn, swapped him to Brooklyn, where he enjoyed a fine comeback season in 1932. After tailing off again the following year, Wilson's baseball days were numbered. By late 1934 he was with the forlorn Phillies, finishing his career a .307 hitter with 1,461 hits and 244 home runs. Hack died a penniless alcoholic in Baltimore in 1948. The National League paid for his funeral while P. K. Wrigley footed the bill for the cemetery monument. When Wilson was at last elected to the Baseball Hall of Fame in 1979, a great injustice was finally rectified.

George Herman "Babe" Ruth was the most famous larger-than-life figure in baseball during his time (1914–1935). A player who could hit and pitch both, the Bambino boasted a .342 lifetime batting average with 2,873 hits while going 94-46 on the mound. His 60 home runs in 1927 were a major-league record until broken by fellow Yankee Roger Maris in 1961, and his career total of 714 was the standard until Hank Aaron exceeded it in 1974. The reason the Sultan of Swat is included in this volume is because he tormented the Cubs in two World Series. In 1918, as a pitcher for the Red Sox, the Babe beat the Cubs twice, and in 1932 he batted .333 with six RBIs—including the legendary "called shot" home run—as the Yanks swept Chicago in 4 straight. Whether or not he actually did call the home run will likely be debated so long as baseball is our national pastime. (As a personal aside, the author's father was sitting on the third-base side of Wrigley Field's grandstand when Ruth hit that home run. He always stated that from his angle, it did appear that Babe had pointed to center field. The author also knew a Catholic priest who was at the game, but seated at the first-base side. According to him, it looked as if Ruth was pointing towards the Cubs' dugout instead. So, who should the author believe—his father or his priest?)

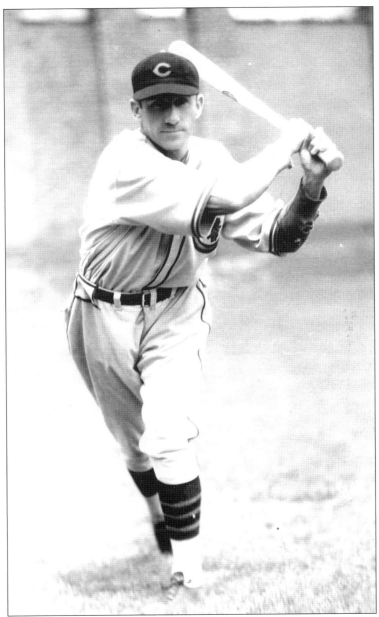

Hazen "Kiki" Cuyler takes batting practice at Wrigley Field around 1930. Cuyler began his career with the Pirates in 1921 and had some outstanding seasons in Pittsburgh, but was dispatched to the Cubs in November of 1927 because he and manager Donie Bush could not get along. One of the finest outfielders the Cubs ever had, Cuyler could hit, field, and run. In his first three years in Chicago, he led (or tied) the league in stolen bases, while from right field he gunned down many a runner at third or home with his powerful arm. Cuyler's most productive campaign overall came as a Cub in 1930 with a .355 batting average, 228 hits, 134 RBIs, and 155 runs scored. He was released mid-season in 1935 and finished his career with the Reds and the Dodgers, retiring in 1938 as a .321 lifetime hitter with 2,299 hits (the same total as Charlie Grimm!) and 328 stolen bases. Cuyler returned to the Cubs as a bench coach in the early 1940s and was elected—somewhat belatedly—to the Hall of Fame in 1968.

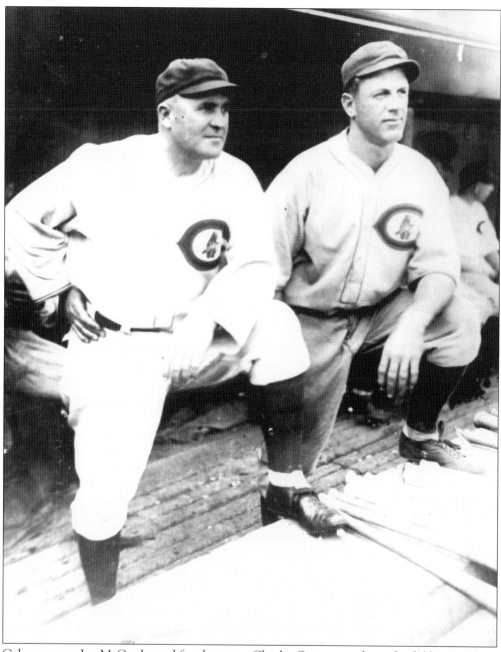

Cubs manager Joe McCarthy and first baseman Charlie Grimm watch on-the-field action from the home dugout in 1927. McCarthy inherited a team that had finished last in 1925. He made contenders out of them immediately, culminating in the 1929 National League Pennant. Grimm would later serve three terms as Cubs skipper himself.

TWO

Rogers Hornsby Tries but Does Not Succeed

1930–1932

The honeymoon between the Cubs and new manager Rogers Hornsby was short-lived. Unlike McCarthy, who had a firm hand but knew when to lay off, the taciturn Hornsby ran the team like a Puritan schoolmaster. While an outstanding athlete, he was not very adept at handling people. The Rajah had enjoyed success several years earlier while running the Cardinals, but as Cubs field leader he was blunt and sometimes arrogant. Impatient and sarcastic, he demanded perfection and nothing less, regardless of the circumstances.

Not overly popular with his teammates to begin with, Hornsby became even more disliked when he banned all alcohol and tobacco from the Cubs clubhouse. As he browbeat players for unwinding at speakeasies and nightclubs, Hornsby squandered his own money at the racetrack, making him a hypocrite in the eyes of many. With his quick tongue, he alienated nearly every player on the team. At times he even berated Catholic players, which included stars Cuyler and Hartnett, for wearing religious medals around their necks. Reportedly, at least one such incident led to a fist fight.

Fate was especially cruel to Hack Wilson, who became Hornsby's number-one scapegoat when his output plummeted along with the Depression-era stock market. Hack's late-night carousing, which did not sit well with the tee-totaling Rajah, was catching up with him in a major way, resulting in several suspensions. Hornsby also tampered with Wilson's batting style, and while his efforts in this respect were probably well-intentioned, they had the opposite effect as Wilson sulked and drank. In addition to this, the National League baseball had been deadened to its 1928 configuration, resulting in a dramatic fall-off in long balls.

The situation reached a boiling point in early September 1931, when Wilson instigated a fist-fight between Pat Malone and two Chicago sportswriters on a home-bound train after the Cubs had just dropped four straight to the last-place Cincinnati Reds. Suspended without pay for the remainder of the season, Hack finished with a paltry .261 batting average, 13 home runs, and 61 RBIs in 112 games. An irate Hornsby stated, "Hack knows he's through as a Cub, so it would

hardly be fair either to himself or to the team to play him." By December, Wilson was gone from the team.

As for the Cubs, their home-run production nose-dived to 83, less than half of their 1930 total. Although their .289 team batting average and 828 runs scored topped the league, they were hollow statistics as the Cubs wound up an underachieving third despite outstanding performances by Cuyler, Grimm, and English. On a positive note, rookie infielders Billy Jurges and Billy Herman were already showing rare promise.

Regardless of Hornsby's shortcomings as a manager, he was still an asset on the field. Appearing in 100 games, the Rajah tied Grimm for the team's best batting average (.331) while his 16 home runs and 90 RBIs led the pace for the Cubs. On April 24, 1931, he had one of the finest outings of his career, clouting three homers to drive in eight runs as the Cubs sank the Pirates 10-6 at Forbes Field.

The game was on the line on September 13, with the Cubs and Braves knotted up at seven apiece at Wrigley, as Hornsby sat in the dugout. It was the bottom of the 11th and the Cubs had the bases loaded. Coming in cold off the bench, the Rajah smacked a grand slammer for an 11-7 Cubs win.

When asked why he put himself in at such a potentially embarrassing tight-spot, he replied in typical Hornsbian fashion: "I needed the best hitter on the team, so I put myself in." His comment probably did nothing to endear him with his players.

The year 1932 began on a sad note with the death of William Wrigley at the age of 70 on January 26, leaving the team in the hands of his son, Phillip, and president William Veeck Sr. Veeck was not remotely as enamored with Hornsby as the elder Wrigley had been, and the two soon began falling out.

As the baseball season began, Hornsby now did most of his managing from the bench, rarely appearing in the lineup. While such young stars as Herman, Jurges, and pitcher Lon Warneke played sterling baseball, the Cubs seemed unable to jell as a team. As the weeks went on, the Rajah's relations with Veeck and the players continued to deteriorate.

Rumors—and finally an investigation—concerning Hornsby's gambling habits did not help his position either. His reign as Cubs manager would soon pass into history.

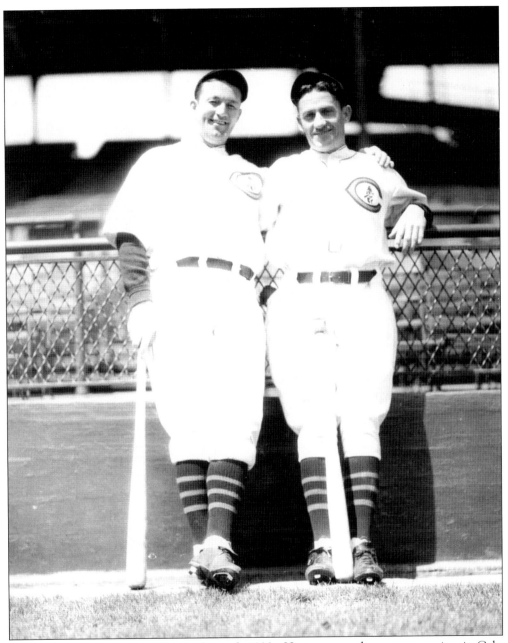

Gabby Hartnett poses with Kiki Cuyler, early 1930s. Hartnett was the greatest receiver in Cubs annals (and one of the best ever, period!), while Cuyler was one of their finest outfielders. Bob Elson, who broadcast Cubs baseball on the radio from 1930 through 1942, regarded Cuyler as the best all-around player he ever saw in a Cubs uniform. Both of these players are in the Hall of Fame, and rightfully so.

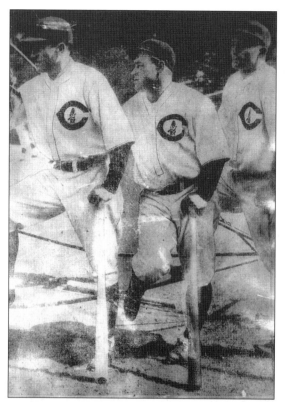

Here is a rare view, from left to right, of the great Cubs outfield of Kiki Cuyler, Hack Wilson, and Riggs Stephenson. Although they were together as a trio for only four seasons (1928–1931), their individual contributions to the team spanned nearly a decade.

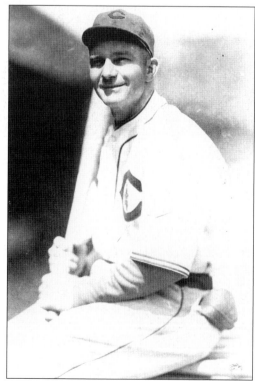

Riggs Stephenson joined the Cubs, along with Hack Wilson, in 1926. He stuck around through 1934.

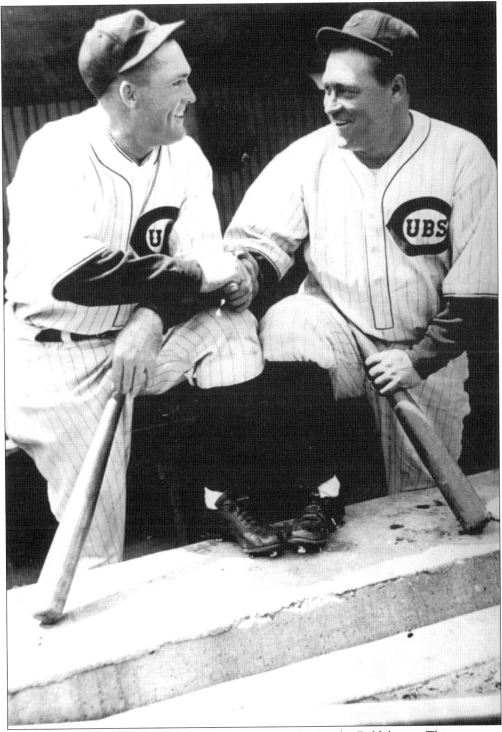

Rogers Hornsby (left) and Hack Wilson shake hands in the Wrigley Field dugout. This scene was obviously posed, as the two strongly disliked each other in actual life.

Rollie Hemsley was second-string catcher to Gabby Hartnett during the 1931 and 1932 seasons. His chief claim to fame as a Cub was getting arrested three times in one night for being "drunk and disorderly."

James "Zack" Taylor was another Cubs backup catcher between 1929 and 1933. There seems to be some substance other than Wrigley's chewing gum within his cheeks.

CHICAGO NATIONAL LEAGUE BALL CLUB
EST. 1876

CUBS

10¢

OFFICIAL SCORE CARD

WRIGLEY **FIELD**

The Blue Streak

CHICAGO'S SPORTS FINAL

For box scores, running stories, race charts—
results from every important diamond, track,
gridiron and arena.

. . . And accuracy, completeness and sports-
speed in all news fields.

THE CHICAGO DAILY NEWS
Chicago's Home Newspaper

Here is a game-day program from an early 1930 match-up with the Cubs hosting the Phillies at Wrigley Field. At 10¢, a fan could log the game's progress, inning-by-inning and batter-by-batter, with the scorecard provided within. *The Blue Streak* was a sports finale issued by the *Chicago Daily News*, a popular afternoon daily of the day. Other sponsors of the era—some familiar to today's fans, some not—included Coca Cola, Camel Cigarettes, and (after the repeal of Prohibition) "cool, foamy" Prima Beer. Note the playful Cubby Bears within the "CUBS" lettering.

Here is the program and scorecard from a 1931 Cubs-Reds match-up at Wrigley Field.

Someone apparently attempted to keep score at this Cubs-Dodgers game in the early 1930s, but the eraser marks and absence of final tally imply that he or she may have given up before the final frame. Note the Green River advertisement—for soda pop—along with a full back-page ad for Blue Valley Butter (not pictured), suggesting this undated program was from a Prohibition-era ball game.

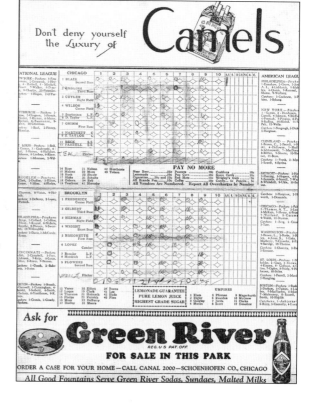

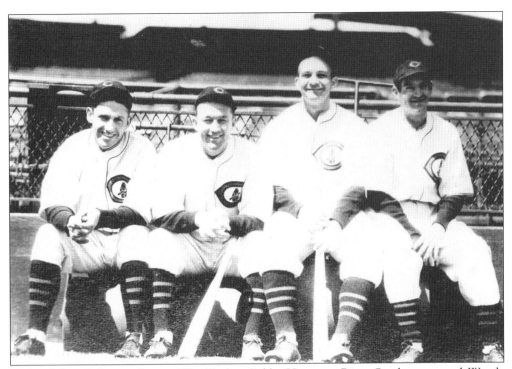

Pictured from left to right are Kiki Cuyler, Gabby Hartnett, Riggs Stephenson, and Woody English relaxing at Wrigley Field in the early 1930s.

Lon Warneke was among the best Cub pitchers of the Great Depression–era. With the Cubs from 1930 through 1936, the tobacco-chewing right-hander won 100 games while losing only 59. He assembled three 20-win seasons—22-6 in 1932, 22-10 in 1934, and 20-13 in 1935. In April 1934, he hurled two consecutive one-hit games. Warneke was traded to the Cardinals (where he tossed a no-hitter in 1941) after the 1936 season and returned to the Cubs in 1942 as a spot starter. He retired in 1945 with a 193-121 log and later became a National League umpire.

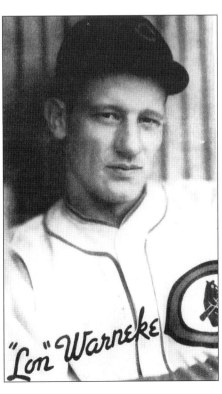

Chicago Cub stars of the era with their autographs, are Charlie Grimm (left), and Hack Wilson (below).

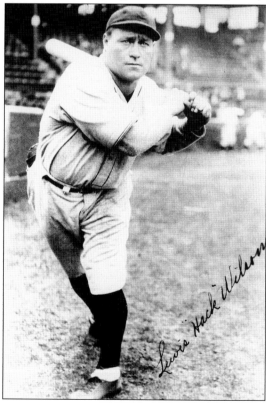

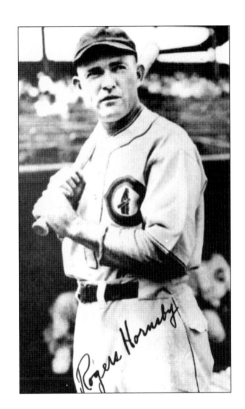

Two other stars are Guy Bush (below), and Rogers Hornsby (right).

Billy Jurges joined the Cubs in 1931 and became their regular shortstop the following year. Although a light hitter—his highest average was .298 in 1937—Jurges more than compensated for it with his vacuum glove and swift arm. When Charlie Grimm stepped down as team manager in mid-1938, Jurges, a favorite of Cubs owner Phillip K. Wrigley, declined an offer to skipper the club. This led to Billy being dealt to the Giants in a move that left the Cubs weak at shortstop until the arrival of Ernie Banks.

Hall of Fame second baseman Billy Herman snags a high-line drive in this posed c. 1932 photograph at Wrigley Field. A Cub from August 1931 to May 1941, Herman was a consistent .300 hitter plus an outstanding glove man. His 227 hits in 1935 were a league high, while his 57 doubles (duplicated the following year) remain a club record. Traded to Brooklyn in 1941, Herman also played for the Braves and Pirates before retiring in 1947. He was a lifetime .304 hitter with 2,345 hits.

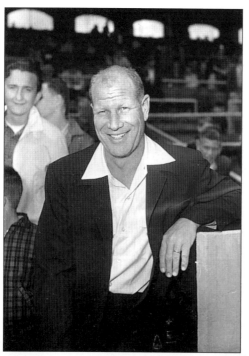

Phillip K. Wrigley became owner of the Cubs upon his father's death in 1932, and assumed the club presidency three years afterward. Wrigley was a genius when it came to running the gum company and also did an excellent job in maintaining the beauty of the ballpark. As for his abilities as president of a major league baseball club, the less said the better.

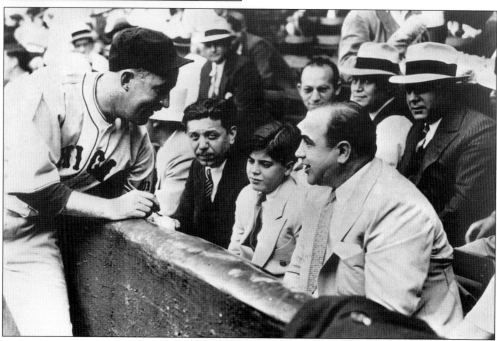

Gabby Hartnett is seen here with another renowned Chicagoan, Al Capone, at Comiskey Park for the 1930 City Series with the White Sox. Ever aware of good public relations, Capone supplied the Cubs and Sox clubhouses with prohibited refreshments—free of charge. When summoned to Commissioner Kenesaw M. Landis' office to explain himself, Hartnett said, "Judge, if you don't want me to have my picture taken with the big guy, *you* tell him." And no one disputed Capone's claim of being the number one Cub fan in Chicago.

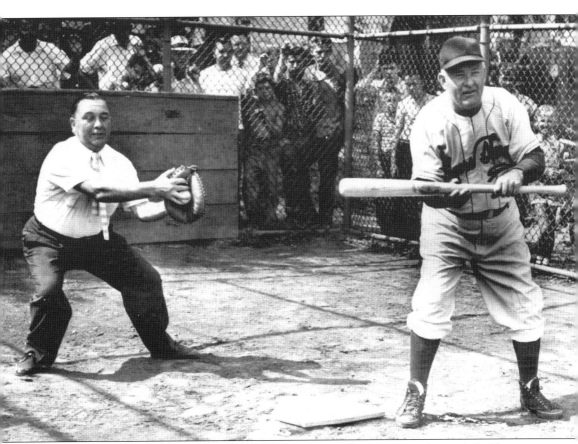

In an unidentified city park, an older, mellower Rogers Hornsby attempts to bunt while Chicago mayor Richard J. Daley catches in 1955. At the time, Hornsby was baseball director of the mayor's Youth Foundation. By 1958, the Rajah was back with the Cubs organization as a combination scout and coach, and was influential in the development of future stars Ron Santo and Billy Williams.

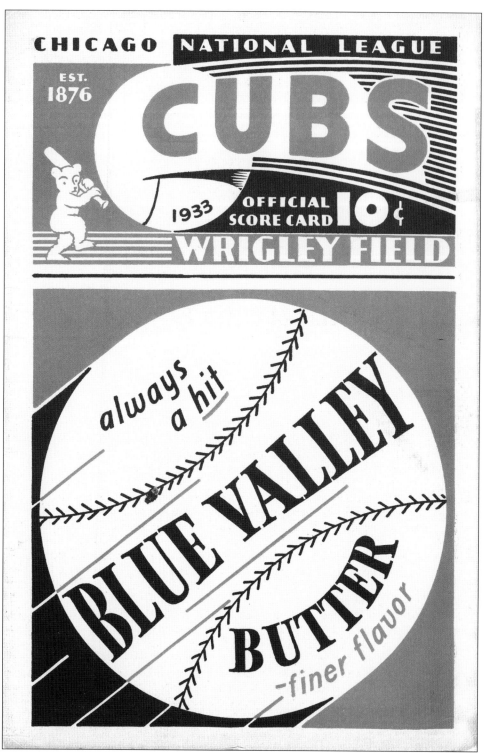

This program from April 13, 1933, was from a Cubs match-up against former field boss Rogers Hornsby and his St. Louis Cardinals at Wrigley Field.

THREE

The Not So Grim Years of Charlie Grimm
1932–1938

By mid-1932, the Cubs were a distant second and going nowhere. Resentment against Hornsby's rule was reaching a dangerous level as many of the players were approaching open revolt. Finally, the front office saw the smoke signals and replaced him with Charlie Grimm in early August. At the time, the team was five games out of first place with a 53-44 record.

Grimm's first act was to rescind Hornsby's ban on alcohol and tobacco, which immediately created a more relaxed atmosphere in the clubhouse. In contrast to the Cromwellian Hornsby, Grimm let the team run itself whenever possible, cracking the whip only when all else had failed. His immense popularity among his teammates also made the transition a welcome one. As a harbinger of things to come, the Cubs clouted the Phillies 12-2 on "Jolly Cholly's" first day in the driver's seat. By August 16, the team had loosened up and was ready for Charlie Grimm Day at Wrigley Field. With the Cubs behind 3-0 in the last of the 9th, shortstop Billy Jurges reportedly said, "C'mon guys, we can't lose this one for Charlie." They rallied for a 4-3 win, with Jurges knocking home the winning run.

On the impetus of a 14-game winning streak and the hot bats of Kiki Cuyler and a recently purchased Mark Koenig (.353 in 33 games), the Cubs crashed into the lead and won the flag. They clinched it on September 20, 1932, with a 5-2 victory over the Pirates at Wrigley Field. Cuyler's bases-loaded triple in the 7th inning broke a tie game as Guy Bush went the distance for his 19th win. Under Grimm's leadership, the Cubs had gone 37-20 to finish at 90-64, four games ahead of Pittsburgh. Charlie contributed a .307 batting average to the cause.

The season also witnessed the emergence of Lon Warneke, Billy Herman, and Billy Jurges as major contributors. Warneke, who had gone 2-4 in 1931, led the league in wins (22), winning percentage (.786), ERA (2.37), and shutouts (4). Herman, in his first full year at second base, came through with a .314 batting average. Jurges, who pushed Woody English to third base, led all National League shortstops in fielding average and chances per game.

The Cubs opponents in the World Series were the New York Yankees of Babe Ruth, Lou

Gehrig, and company, led by former Cubs manager Joe McCarthy. For Marse Joe, it would be sweet revenge.

The Cubs went into the Series as underdogs, and came out the same way. They had voted former Yankee Mark Koenig only half a share of the Series money (at least he fared better than Hornsby, who was voted nothing), and this misguided lack of generosity only inspired the Bronx Bombers to play all the harder.

Following two easy victories in New York, the Series moved to Wrigley Field on Saturday, October 1, 1932. Among those in attendance were Chicago Mayor Anton Cermak and Franklin D. Roosevelt, the soon-to-be-elected president. Babe Ruth hit an early three-run homer off starter Charlie Root, but the Cubs had tied the game 4-4 after four innings.

In the top of the fifth, with two strikes on him, Ruth supposedly "called his shot" by pointing to center field before hitting the home run that soon turned into baseball legend. Ruth's teammates were adamant that he did point to center field, while the Cubs were insistent that he was pointing (or making obscene gestures) toward the Chicago dugout. Charlie Root maintained that Ruth was merely holding up his index finger to indicate that he had one more strike to go. Obviously, both sides had an axe to grind.

This much is certain: Ruth did hit the home run, Lou Gehrig followed with another, and New York went on to win 7-5. After a 13-6 trouncing the next day, the Yankees had swept the Cubs in four games, with Gehrig batting .529.

If the World Series pulverization had not been bad enough, the 1933 season got off to rocky start when Kiki Cuyler broke his leg in spring training. His fine play after he did finally get back in uniform (.317 in 70 games) only made the Cubs feel worse. Babe Herman, obtained from the Reds in a trade, helped out with a .289 average, 16 home runs, and 93 RBIs, but this was all but cancelled out by his horrendous playing in the outfield.

An inability to win consistently on road trips led the Cubs to a third-place finish. They were a solid 50-27 in the friendly confines but only 36-41 while riding the trains. With the Great Depression at its nadir and 25 percent of the population unemployed, Wrigley Field attendance fell to 594,879, the lowest in 11 years.

On November 21, 1933, the Cubs traded Mark Koenig, Harvey Hendrick, and Ted Kleinhans, plus $65,000, to the Phillies for slugging outfielder Chuck Klein. The organization thought that their long search to fill the vacuum left by the departure of Hack Wilson was over, and for the first half of the 1934 campaign it appeared that they were right. At the All-Star break, Klein was hitting .321 with 19 home runs and 65 RBIs. Unfortunately, a leg injury sustained the day after the All-Star game decimated both his performance and his playing time, as he finished at .301 with a disappointing 20 homers and 80 RBIs. And as Klein went, so went the Cubs. They won only 16 of their last 35 games to finish third behind the pennant-winning Cardinals.

The season did have numerous bright spots. Lon Warneke, en route to another 22-win year, pitched back-to-back one-hitters on opening day and in his next start. Kiki Cuyler, in his last full year as a Cub, batted .338 to lead the team while his 42 doubles tied for best in the league. As a team, the Cubs poled 101 four-baggers, their highest total in four years. Not until 1950 would a Cubs team again cross the century mark in home runs.

In the meantime, a massive changing of the guard was taking place. After seeing only limited action in the previous two seasons, Stan Hack became the regular third baseman in 1934 and retained the job for the next dozen years. Outfielder Frank Demaree, who had also debuted in 1932, was back for keeps by 1935. Pitcher Bill Lee and outfielder Augie Galan came up in 1934, both proving themselves quickly. Late in the season, young Phil Cavarretta arrived to aid the aging Charlie Grimm at first base.

During the winter of 1934–1935, veteran hurlers Bush and Malone were dealt away, while Stephenson was released. Larry French and Tex Carleton replaced Bush and Malone, and veteran Freddie Lindstrom was picked up as a utility man. By July 1935, Cuyler would also be gone.

The revamped Cubs looked like a powerhouse on paper as 1935 unfolded, but took time in gathering steam. After going hitless in the first two games, Charlie Grimm took himself out of the

lineup and turned first base over to Cavarretta. The slumping Klein was often benched as well.

For a while the team continued to sputter. But the Cubs became white hot in July, going 20-5 at home with an 11-game winning streak to push themselves near the top. However, when they played only .500 ball in August, they fell back to third.

This was where the Cubs stood on September 4, 1935, when the superstitious Grimm began nailing tacks into his shoes. As he eventually pounded in 21 tacks, the Cubs hammered out 21 straight victories to take the pennant by four games over the Cardinals. The flag was clinched with a September 27 double-header win over the Redbirds, 6-2 and 5-3, at Sportsman's Park in St. Louis. Larry French and Bill Lee each won five games during the streak, Root and Warneke four apiece, rookie Roy Henshaw two, and Tex Carleton one. Warneke and Lee were 20-game winners, as the Cubs ended the season at 100-54 for their most wins in a single season in 25 years.

The Cubs entered the World Series as slight favorites over the Tigers, but the post-season jinx refused to go away as Detroit took the Series in six games. Only Lon Warneke, with victories in the first and fifth contests, was able to tame the Bengals. After winning 21 in a row, the Cubs were mathematically overdue for a bad streak. Unhappily, it came at the wrong time.

In 1936 Wrigley Field was friendlier than ever to the Cubs as they lost only one home game during June. Grimm's warriors surged into first place with 15 consecutive wins, 11 of which came at home. Overall, the Cubs were 50-27 in Chicago, but 37-40 when packing their bags. The Giants took the pennant as the Cubs and Cardinals finished in a tie for the runner-up slot.

Frank Demaree was the team's leading batter at .350 and nosed out Billy Herman in hits, 212 to 211. Herman, who hit .334, amassed 57 doubles for the second straight year. In May, Chuck Klein was dealt back to the Phillies, where he experienced an injury-free comeback. When Lon Warneke slipped to "only" 16-13, he was swapped to the Cardinals for aging first baseman James "Rip" Collins in a questionable trade.

As the modern Wrigley Field bleachers were under construction in 1937, the Cubs made a stronger run for the championship despite having no spectacular winning streaks. Led by Gabby Hartnett's .354 batting average—which included a 26-game hitting streak—the Cubs took over first place on June 15 and held on until the Giants turned up the heat in mid-September. They fell short of the flag by a scant three games. Gabby also got his first taste of managing, running the team for several weeks when Grimm was recuperating from an ailment.

Meanwhile, Lon Warneke won 18 games for St. Louis while Rip Collins suffered a broken leg during the stretch drive for Chicago. As the Cubs pitching was not quite up to par that season, the presence of Warneke was sorely missed.

By April 1938 the soon-to-be familiar vines were beginning to bloom on the recently completed Wrigley Field bleacher walls. The man responsible for this was future White Sox owner Bill Veeck Jr. The Cubs, however, were off to their slowest start in several years as change, once again, was in the wind.

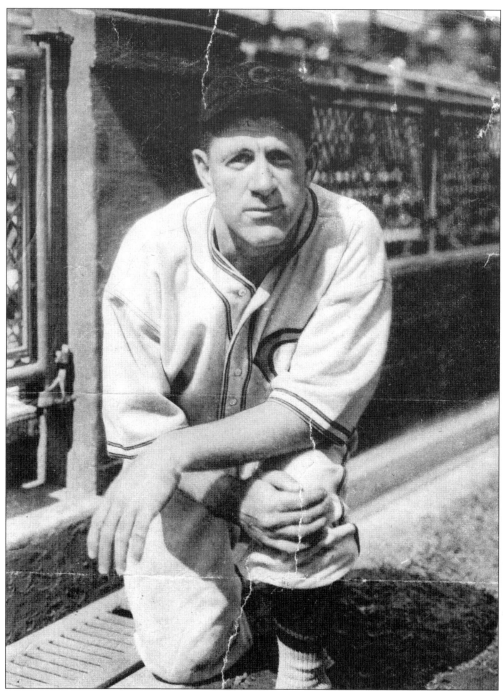

This portrait of Charlie Grimm dates to about 1935. By that time, Grimm was appearing on the field only occasionally and would retire from playing entirely after the 1936 season. One of the most beloved Cubs of all time, Grimm played first base for the team since 1925, following brief stops with the Athletics and Cardinals and six years as a Pirate. A frequent .300 hitter, Jolly Cholly was also an outstanding glove man who often led the league in numerous defensive categories. His best season as a Cub at the plate was 1931, when he batted .331 with 176 hits.

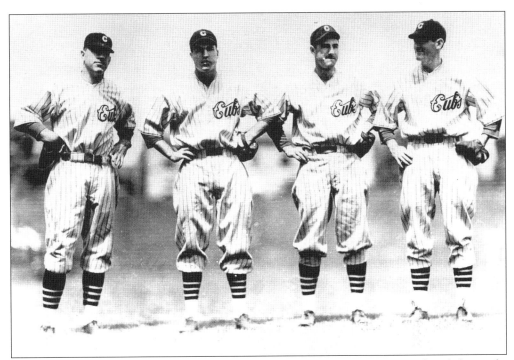

The 1932 Cub infield—easily one of the greatest in the team's history—posing from left to right are first baseman Charlie Grimm, second baseman Billy Herman, shortstop Billy Jurges, and third baseman Woody English. Herman is in the Hall of Fame.

Shown here is a very young Stan Hack, indicating that the photograph was probably taken in his rookie season of 1932. A third baseman, Smiling Stan played his entire career as a Cub, retiring in 1947 with a .301 lifetime batting average and 2,193 hits. He scored 100 or more runs in 6 consecutive seasons (1936–1941), and in 1942 played a then-record 54 straight games without committing an error. It was said that he had as many friends in baseball as Leo Durocher had enemies; surprisingly, he is not in the Hall of Fame.

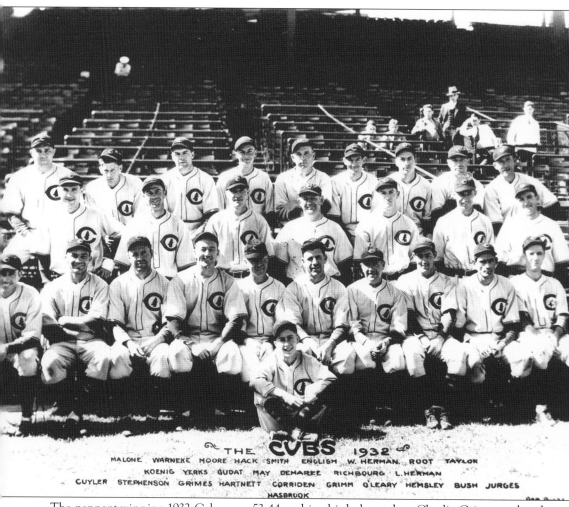

THE CUBS 1932

MALONE WARNEKE MOORE HACK SMITH ENGLISH W. HERMAN ROOT TAYLOR
KOENIG YERKS GUDAT MAY DEMAREE RICHBOURG L. HERMAN
CUYLER STEPHENSON GRIMES HARTNETT CORRIDEN GRIMM O'LEARY HEMSLEY BUSH JURGES
HASBROOK

The pennant-winning 1932 Cubs were 53-44 and in third place when Charlie Grimm replaced Rogers Hornsby as manager on August 2. Relieved of the Rajah's puritanical rule, the Cubs rallied to go 37-20 under Grimm, including a 14-game winning streak in August and September. Kiki Cuyler, in the timeliest hot streak of his career, batted .365 from August 27 to the end of the season. Another sparkplug was Mark Koenig, who hit .353 in 33 games during the stretch as a replacement for shortstop Billy Jurges. (The latter was recovering from gunshot wounds perpetrated by an embittered ex-girlfriend.) Although the 1932 Cubs had a fine team, they were no match for the New York Yankees, who steamrolled Chicago in four straight in the World Series.

Charlie Grimm takes a practice swing for the camera in this early 1930s snapshot. Grimm was a .290 lifetime batter with 2,299 hits, and he led the Cubs to three pennants as a manager. Sadly, he continues to be ignored by the Hall of Fame.

Cubs ace Lon Warneke is shown here decked out in the official National League uniform for the first-ever All-Star game at Comiskey Park, 1933. The "league" uniforms were never used again.

Gabby Hartnett poses in his 1933 All-Star game uniform. He appears to be looking forward to the game.

Gabby HARTNETT

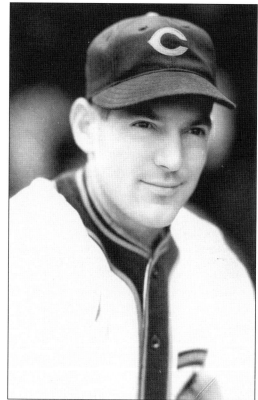

Woody English is seen here in 1933, when he was named to the National League's first All-Star team along with Cubs teammates Hartnett and Warneke.

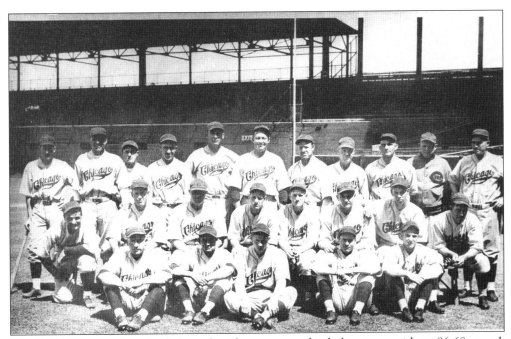

The 1933 Cubs, seen here in their road uniforms, were a third-place team with an 86-68 record. Pennant hopes were largely dashed when Kiki Cuyler broke his ankle in spring training.

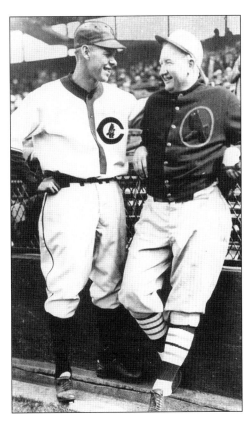

Outfielder Floyd "Babe" Herman (left) visits with former Dodger teammate Dazzy Vance at Wrigley Field in 1933. A heavy hitter but horrendous fielder, Herman entered the majors in 1926 and spent six years in Brooklyn and one in Cincinnati before coming to Chicago. He hit well as a Cub—smashing three home runs in one game and hitting for the cycle in another—but his frequent defensive lapses made him more of a liability than an asset. Babe was let go after the 1934 season.

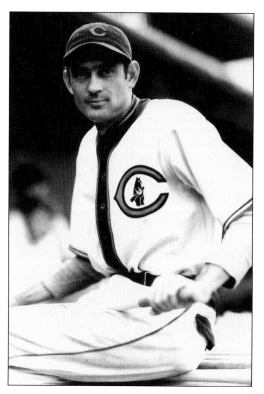

Cubs pitcher Guy Bush is pictured here in 1933, his best season. Reportedly given 16 "lucky" four-leaf clovers by some fans, Bush responded with a 20-12 log and a 2.75 ERA. Nicknamed the "Mississippi Mudcat," Bush started with the Cubs in 1923 and won 152 games for them over 12 years. After bouncing around with the Pirates, Braves, Cardinals, and finally the Reds, Bush retired in 1945 as a 176-136 lifetime hurler. Guy later owned a tavern on Chicago's North Side.

Cubs outfielder Babe Herman looks somewhat bemused in this 1934 photograph.

Augie Galan is seen here in his early Cubs years, which began in 1934. Originally a second baseman, Galan was soon converted to an outfielder since the team already had Billy Herman. Due to his proneness to injuries, Augie did not fully live up to expectations but still had a fine career, which included a .314 mark in 1935 and .304 in 1939. During the former season the speedy Galan played the entire 154 games (646 at-bats) without hitting into a double play, a major league record. He made history again on June 25, 1937, when he became the first Cub to homer from both sides of the plate. Galan later played for the Dodgers, Reds, Giants, and Athletics, retiring in 1949 with a .287 career batting average and 1,706 hits.

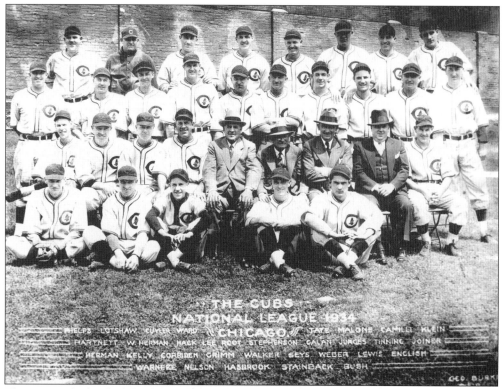

The 1934 Cubs finished third again with a record of 86-65. As had been the case in years before, an injury to a key player (this time Chuck Klein) hurt the club immensely.

Hall of Famer Chuck Klein was one of baseball's premier hitters during his first term with the Phillies, from 1928 through 1933. His stay with the Cubs, beginning in 1934, was a disappointment by comparison, thanks to a leg injury that kept him on the bench. By May 1936, Klein was back in Philadelphia.

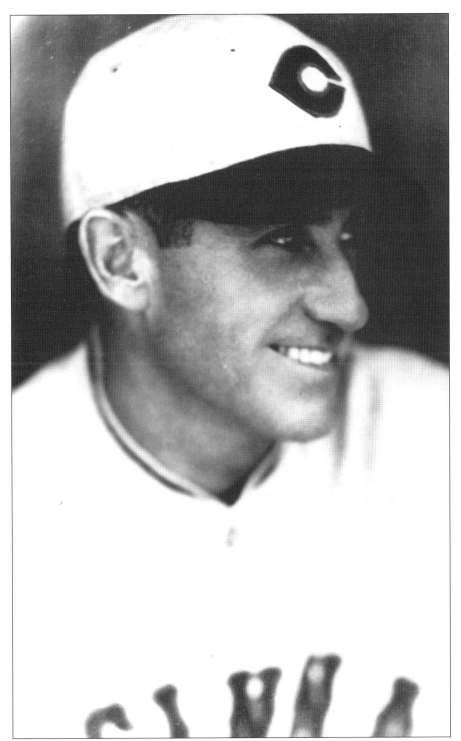

Former Cubs star Kiki Cuyler is seen here as a Cincinnati Red. Cuyler played with the Reds from July 1935 through 1937. In 1936, he enjoyed his last great season, batting .326 with 186 hits in 144 games for the river city. The Cubs could have used his bat that season.

CHICAGO CUBS

Baseball Schedule

1934

●

STANLEY

AT HOME

Apr. 24, 25, 26—Cincinnati	July 2, 3,—St. Louis
Apr. 27, 28, 29—St. Louis	July 5, 6, 7, 8—Pittsburgh
May 3, 4, 5—Boston	July 31-Aug. 1, 2—St. Louis
May 6, 7, 8—Philadelphia	Aug. 3, 4, 5—Cincinnati
May 9, 10, 11, 12—Brooklyn	Aug. 14, 15, 16, 17—Boston
May 13, 14, 15—New York	Aug, 18, 19, 20, 21—Phila.
May 30, 30, 31—Pittsburgh	Aug. 23, 24, 25—Brooklyn
June 8, 9, 10—Cincinnati	Aug. 26, 27, 28, 29—N. Y.
June 12, 13, 14, 15—Phila.	Aug. 31-Sept. 1, 2—St. Louis
June 16, 17, 18, 19—Boston	Sept. 25, 26—Cincinnati
June 20, 21, 22, 23—N. Y.	Sept. 27, 28, 29, 30—Pitts.
June 24, 25, 26, 27—Brook.	

ABROAD

Apr. 17, 18, 19 at Cincinnati	July 14, 15, 17, 18 at N. Y.
Apr. 20, 21, 22 at St. Louis	July 19, 20, 21, 22 at Phila.
Apr. 30-May 1, 2 at Pitts.	July 23 24, 25, 26 at Brook.
May 17, 18, 19 at Phila.	July 28, 29, 30 at Cincinnati
May 20, 21, 22 at Brooklyn	Aug. 7, 8, 9 at Pittsburgh
May 23, 24, 25 at New York	Aug. 10, 11, 12 at St. Louis
May 26, 27, 28 at Boston	Sept. 3, 3 at Cincinnati
June 1, 2, 3 at Cincinnati	Sept. 5, 6, 7, 8 at New York
June 5, 6, 7 at St. Louis	Sept. 9, 10, 11, 12 at Boston
June 29, 30-July 1 at Pittsb'gh	Sept. 13, 14, 15, 16 at Brook.
July 4, 4 at St. Louis	Sept. 17, 18, 19, 20 at Phila.
July 11, 12, 12, 13 at Boston	Sept. 22, 23 at Pittsburgh

RICHARD

GEO STA

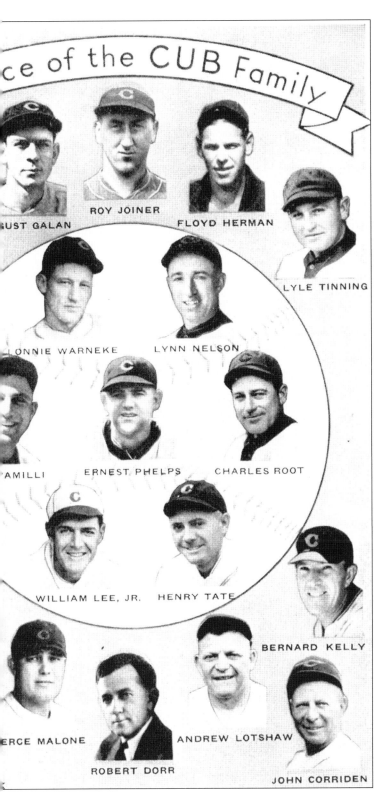

ce of the CUB Family

GUST GALAN

ROY JOINER

FLOYD HERMAN

LYLE TINNING

LONNIE WARNEKE

LYNN NELSON

CAMILLI

ERNEST PHELPS

CHARLES ROOT

WILLIAM LEE, JR.

HENRY TATE

BERNARD KELLY

PIERCE MALONE

ROBERT DORR

ANDREW LOTSHAW

JOHN CORRIDEN

This spread from a 1934 booklet about the Cubs, "published for the benefit of baseball fandom," shows that season's schedule (left) and key members of the team and team management. Notice that compared to today, with far more teams and inter-league play, the Cubs back then faced the same seven opponents again and again.

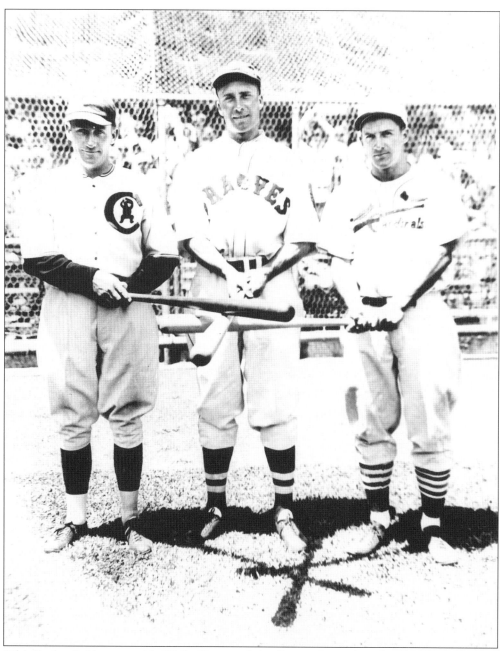

Kiki Cuyler (left) poses with Wally Berger of the Braves (center) and Joe Medwick of the Cardinals at the 1934 All-Star game in New York's Polo Grounds. All three had all-star seasons as well. Cuyler batted .338 for the Cubs to lead the team; Berger hit .298 with 34 home runs and 121 RBIs; and Medwick was a .319 hitter with 106 RBIs and a league-leading 18 triples. Although the American League won the 1934 All-Star Game 9-7, it is best remembered for the Giants's Carl Hubbell striking out Babe Ruth, Lou Gehrig, Jimmy Foxx, Al Simmons, and Jim Gronin in succession. Hubbell's catcher was Cubs-great Gabby Hartnett.

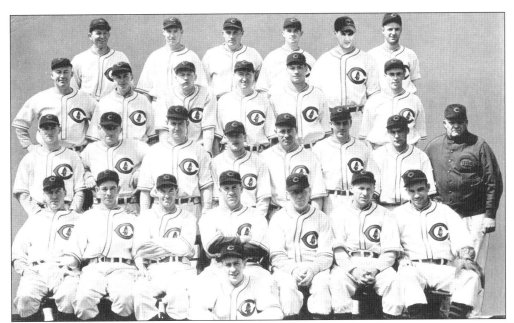

The 1935 Cubs won the pennant by way of a 21-game winning streak in September, tying the club record set in 1880 by Cap Anson's first championship team. They finished 100-54, paced by MVP Gabby Hartnett's .344 batting average and Billy Herman's .341. That season the Cubs led the league in hitting with .288 team mark. Lon Warneke and Bill Lee were both 20-game winners. But the team ran out of gas in the World Series, losing to Detroit in six games.

Frank Demaree was a Cubs outfielder from 1932 through 1938, having his best seasons in 1935, 1936, and 1937, when he batted .325, .350, and .324. On July 5, 1937, he collected 6 hits in 7 at-bats, including 3 doubles, as the Cubs out-slugged the Cardinals 13-12 in 14 innings at Wrigley Field. Batting cleanup, Demaree drove in 115 runs that year to pace the team. He later played for the Giants, Braves, Cardinals, and Browns but never approached the glory he enjoyed as a Cub. He retired in 1944 with a .299 lifetime average and 1,241 hits.

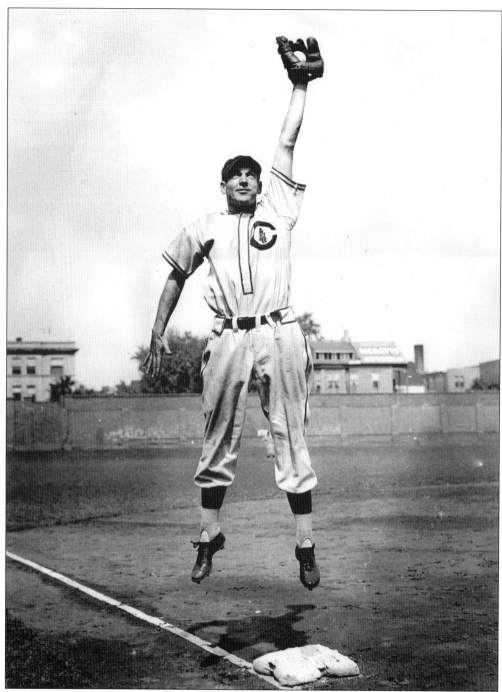

Cubs third-baseman Elwood "Woody" English makes a leaping catch in a posed picture at Wrigley Field in 1935. English began as a rookie Cubs shortstop in 1927, but in the early 1930s he was moved to the hot corner to make room for Billy Jurges. He returned to shortstop for a month and a half in 1934 when Jurges was sidelined with appendicitis. Woody was also one of the few players to get along with Rogers Hornsby during the Rajah's days as a Cub (1929–1932).

Pitcher Larry French is seen here in 1935 or 1936, the last year of the jersey with the wishbone "C." After seven seasons with the Pirates, the left-handed French came to the Cubs via the trade route in 1935 and contributed 17 wins to the pennant winners. He remained the team's top southpaw until waved into the Dodgers in late 1941. For Brooklyn, he went 15-4 in 1942. He then became a lifer in the Navy, leaving behind a record of 197-171.

After pitching for the Cubs briefly in 1933, University of Chicago graduate Roy Henshaw blossomed into a 13-game winner with just five losses for the 1935 National League champions. On June 28 he came within a hair's breadth of throwing a no-hitter in an 8-0 shellacking of the Pirates at Wrigley Field. The lone hit came on Mace Brown's sixth-inning double that even center fielder Freddie Lindstrom, who muffed the ball, thought should have been charged an error.

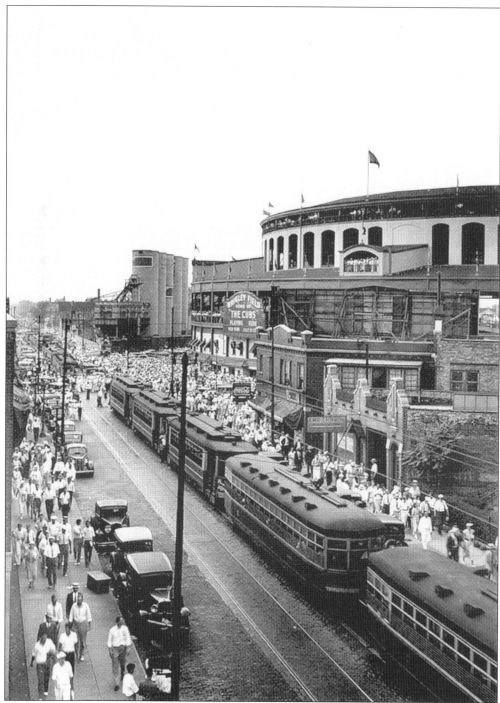

Wrigley Field is seen here buzzing with activity for a double-header with the Giants in July 1935. Five street cars are lined up along Clark Street. As Chicago's last streetcar line, the Clark trolley continued to transport Cubs fans to and from the ballpark until June 22, 1958. The coal bins shown at left came down not long thereafter. As for the double-header, the Cubs won both games, 5-4 and 11-5.

Chicago-born Freddie Lindstrom is depicted here in 1935, his only year as a Cub. Lindstrom, who had his best years with the Giants, batted .275 in 90 games as a utility man for the 1935 pennant winners.

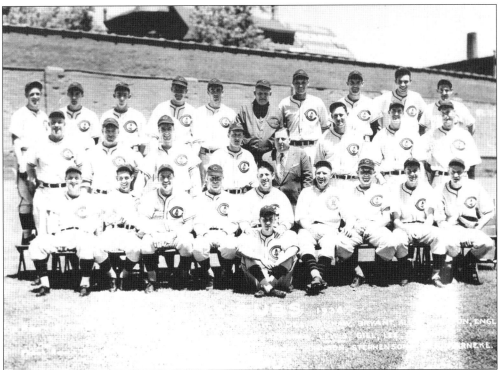

The Cubs of 1936 looked like they would repeat as flag winners, holding first place well into July. However, a mediocre second half dropped them into a tie for second place with the Cardinals at 87-67.

Cubs outfielder Ethan Allen is pictured in 1936, his only year with the team. While Allen enjoyed a good career, most of it occurred elsewhere. A major leaguer for 13 years (1926–1938), Ethan also played for the Reds, Giants, Cardinals, Phillies, and Browns, retiring a lifetime .300 batter with 1,325 hits.

Cubs catchers, pictured here, are, from left to right, Ken O'Dea, Gabby Hartnett, Walter Stephenson, and Harold Sueme at Catalina Island in 1936. O'Dea was a backup to Hartnett while Stephenson was third string. Sueme was dropped from the roster after spring training and never made it to the majors.

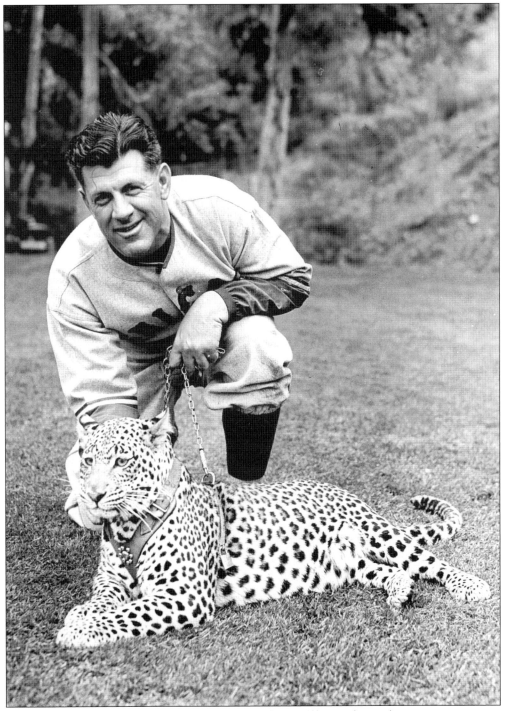

By now strictly a bench manager, Charlie Grimm shows off his pet leopard at spring training on Catalina Island in March 1937. Whether or not the big cat was employed to discipline unruly players is unknown. The cat's name has also been lost to history.

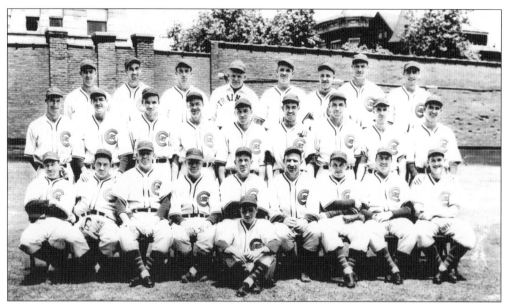

The 1937 Cubs finished an ever-so-close second (three games) to the Giants with a 93-61 ledger. Although they batted .287 as a team, the pitching was not up to its normal form. The staff ERA of 3.97 was sixth in the league, which hurt the club in the long haul.

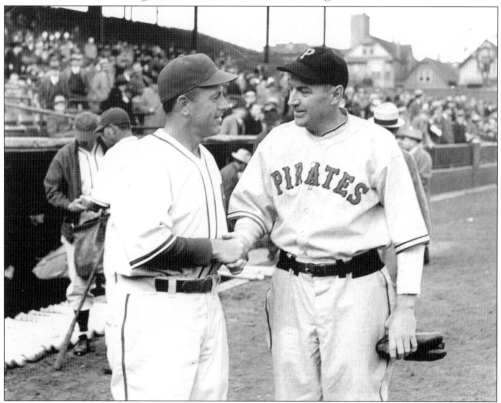

Charlie Grimm shakes hands with Pirates third-baseman and manager Harold "Pie" Traynor at Wrigley Field in 1937. The Pirates finished third behind the second-place Cubs.

Pictured here is former Cubs left-handed ace Jim "Hippo" Vaughn, who was the team's batting-practice pitcher in 1937. In his younger days, Vaughn had won 151 games for the Cubs from 1913 through 1921, including five 20-win seasons between 1914 and 1919.

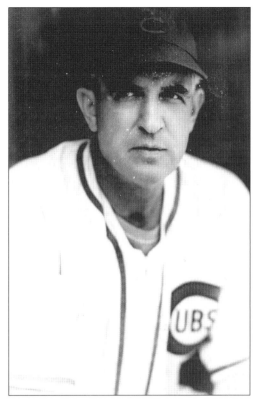

In this image, pitcher Tex Carleton (left), backup catcher Ken O'Dea (center), and first baseman Rip Collins (right) pose in front of the Wrigley Field batting cage in 1937. The Cubs featured new uniforms that year that replaced the bear in the wishbone "C" with a round red "C" enclosing blue "UBS" lettering.

NATIONAL LEAGUE

BOSTON—Pitchers: 1-MacFayden, 2-Lanning, 3-Bush, 4-Weir, 5-Babich, 6-Reis, 7-Harris, 8-Frasier, 9-Smith, R., 10-Fette, 11-Hutchinson, 12-Sewell, 13-Turner.
Catchers: 1-Lopez, 2-Mueller, 3-Andrews.

BROOKLYN — Pitchers: 1-Mungo, 2-Frankhouse, 3-Clark, 4-Birkofer, 5-Henshaw, 6-Jeffcoat, 7-Eisenstat, 8-Butcher, 9-Baker, 10-Hamlin, 11-Signer, 12-Peterson.
Catchers: 1-Gautreaux, 2-Phelps, 3-Klumpp, 4-Moore.

CINCINNATI—Pitchers: 1-Derringer, 2-Hallahan, 3-Hollingsworth, 4-Schott, 5-Brennan, 6-Davis, R. 7-Vander Meer, 8-Grissom, 9-Moore, L., 10-Mooty.
Catchers: 1-Lombardi, 2-Davis, V.

NEW YORK—Pitchers: 1-Hubbell, 2-Schumacher, 3-Fitzsimmons, 4-Gumbert, 5-Smith, 6-Gabler, 7-Coffman, 8-Castleman, 9-Melton.
Catchers: 1-Mancuso, 2-Danning, 3-Spencer.

PHILADELPHIA—Pitchers: 1-Walters, 2-Mulcahy, 3-Passeau, 4-Kelleher, 5-Johnson, 6-Burke, 7-Jorgens, 8-La Master.
Catchers: 1-Grace, 2-Wilson, 3-Atwood.

PITTSBURGH—Pitchers: 1-Blanton, 2-Lucas, 3-Swift, 4-Weaver, 5-Hoyt, 6-Brandt, 7-Brown, M., 8-Bauers, 9-Tobin, 10-Bowman.
Catchers: 1-Padden, 2-Todd, 3-Epps.

ST. LOUIS — Pitchers: 1-Dean, J., 2-Warneke, 3-Dean, P., 4-Winford, 5-Weiland, 6-Johnson, Si., 7-Haines, 8-Harrell, 9-McGee, 10-Ryba, 11-Cooper, 12-Andrews, 13-Moore, H., 14-Smith, I.
Catchers: 1-Ogrodowski, 2-Owen.

CHICAGO CUBS	1	2	3	4	5	6	7	8	9	10	A.B.	R.	1B	S.H.	P.O.	A.	E.
7 GALAN Left Field																	
4 HERMAN Second Base																	
3 COLLINS First Base																	
9 DEMAREE Right Field																	
2 HARTNETT C. / 12 O'DEA C.																	
6 HACK Third Base																	
8 MARTY C.F. / 23 CAVARRETTA C.F.																	
5 JURGES Short Stop																	
Pitcher																	

1-Grimm, Mgr. 18-Bryant 42-Stainback
11-Lee 21-Shoun 43-Kimball
14-French 22-Davis 19-Corriden, Coach
15-Frey 24-Parmelee 20-Johnson, Coach
16-Carleton 39-Garbark
17-Root 41-Bottarini

CORD
Super-Charged Models
The Ultimate in Performance

UMPIRES

1-Quigley 6-Magerkurth 11-Parker
2-Klem 7-Barr 12-Ballanfant
3-Reardon 8-Stewart 13-Goetz
4-Pfirman 9-Sears
5-Moran 10-Pinelli

AMERICAN LEAGUE

BOSTON—Pitchers: 1-Ferrell, W., 2-Grove, 3-Ostermueller, 4-Marcum, 5-Walberg, 6-McKain, 7-Ripley, 8-Bowers, 9-Dickman, 10-Henry, 11-Midkiff, 12-Mustaikis, 13-Olson, 14-Poindexter, 15-Rogers, 16-Wilson.
Catchers: 1-Ferrell, R., 2-Desautels, 3-Dickey, Geo. 4-Peacock.

CHICAGO — Pitchers: 1-Kennedy, 2-Stratton, 3-Whitehead, 4-Lyons, 5-Dietrich, 6-Cain, 7-Lee, 8-Chelini, 9-Rigney, 10-Brown, C., 11-Wilshere.
Catchers: 1-Sewell, 2-Shea, 3-Rensa.

CLEVELAND—Pitchers: 1-Feller, 2-Allen, 3-Harder, 4-Whitehill, 5-Hudlin, 6-Galehouse, 7-Brown, L., 8-Andrews, 9-Fischer, 10-Heving, 11-Wyatt, 12-Drake, 13-Kardow, 14-Milnar.
Catchers: 1-Pytlak, 2-Sullivan, 3-Becker, 4-Helf.

DETROIT — Pitchers: 1-Rowe, 2-Bridges, 3-Auker, 4-Lawson, 5-Sorrell, 6-Hatter, 7-Russell, 8-Wade, 9-Gill, 10-Logan, 11-McLaughlin.

ST. LOUIS	1	2	3	4	5	6	7	8	9	10	A.B.	R.	1B	S.H.	P.O.	A.	E.
11 MOORE Center Field																	
6 S. MARTIN Second Base																	
14 BORDAGARAY Third Base																	
7 MEDWICK Left Field																	
23 MIZE (10) First Base																	
1 J. MARTIN Right Field																	
2 DUROCHER Short Stop																	
9 OGRODOWSKI C. / 8 OWEN C.																	
Pitcher																	

Numbers right of players' names correspond with numbers on uniforms.

3-Frisch, Mgr. 17-J. Dean 41-Weiland (20)
4-Padgett 18-Warneke 42-Ryba (19)
5-Gutteridge 21-P. Dean 43-Chambers (31)
12-Johnson 22-Siebert 49-Andrews (29)
15-Brown 24-McGee 51-Harrell (28)
16-Haines 39-Winford (27) 25-Gonzales, Coach 26-Wares, Coach

Catchers: 1-Cochrane, 2-Hayworth, 3-Tebbetts, 4-Treah.

NEW YORK — Pitchers: 1-Gomez, 2-Ruffing, 3-Pearson, 4-Hadley, 5-Murphy, 6-Malone, 7-Broaca, 8-Brown W., 9-Wicker, 10-Chandler, 11-Makosky.
Catchers: 1-Dickey, 2-Glenn, 3-Jorgens.

PHILADELPHIA—Pitchers: 1-Kelley, 2-Turberville, 3-Gumpert, 4-Caster, 5-Ross, 6-Fink, 7-Nelson, 8-Williams, 9-Smith, E., 10-Thomas, L.
Catchers: 1-Hayes, 2-Brucker.

ST. LOUIS — Pitchers: 1-Hildebrand, 2-Hogsett, 3-Knott, 4-Thomas, A., 5-Tietje, 6-Van Atta, 7-Walkup, 8-Koupal, 9-Caldwell, 10-Blake, 11-Trotter, 12-Bonetti.
Catchers: 1-Hemsley, 2-Huffman, 3-Giuliani.

WASHINGTON—Pitchers: 1-Newsom, 2-Weaver, 3-Appleton, 4-Cascarella, 5-DeShong, 6-Kelly, 7-Lanahan, 8-Salveson, 9-Linke, 10-Petticolas, 11-Cohen, 12-Phebus.
Catchers: 1-Bolton, 2-Hogan, 3-Millies, 4-Lee.

Above is the game-day program from a 1937 Cubs-Cardinals Contest at Wrigley Field. The cost was just one dime.

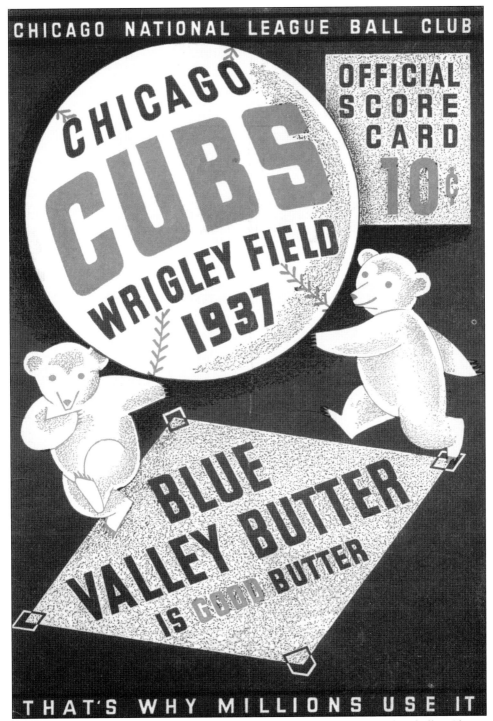

The scorecard inside lists some of the other ballpark prices of Depression-era baseball in Chicago: "Beer . . . 20¢, Hot Sandwich . . . 15¢, peanuts, popcorn, or ice cream . . . 10¢." Also of interest are the starting lineups for all National League and American League ball clubs on either side of the box-score ledger.

William Veeck Jr., seen here in later years, started his career as an editor of *Chicago Cubs News*, a free newsletter, from 1936 to 1940. Veeck would later become owner (in chronological order) of the Milwaukee Brewers (American Association), Cleveland Indians, St. Louis Browns, and Chicago White Sox (twice).

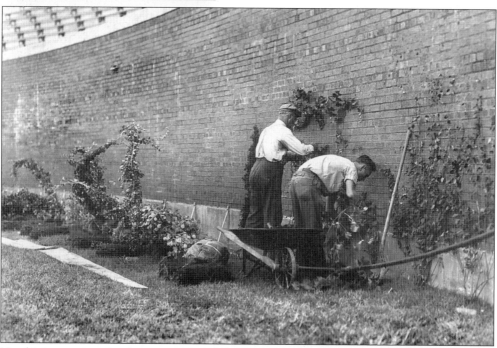

Veeck's innovations for the game included the planting of the Wrigley Field vines in September 1937 (pictured above); signing the first African American player in the American League (Larry Doby) with the Indians in 1947; sending a vertically challenged Eddie Gaddell up to pinch-hit for the Browns in 1951; and installing the exploding scoreboard at Comiskey park in 1960. Although Chicagoans generally associate Veeck with the White Sox, he was actually a lifelong Cubs fan.

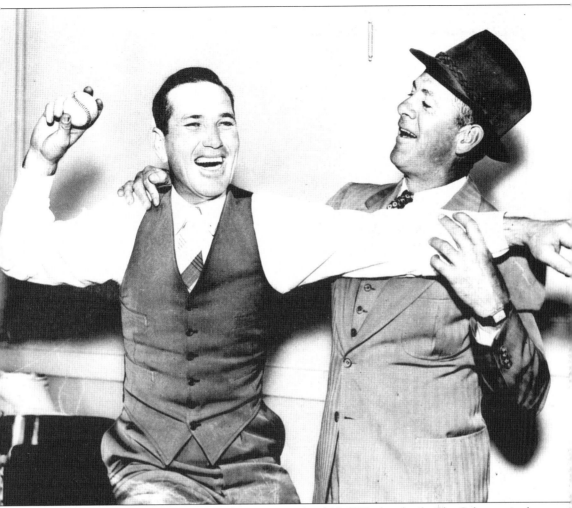

Dizzy Dean (left) and Charlie Grimm chum it up on April 18, 1938, shortly after the Cubs acquired Dean in a trade with the Cardinals. St. Louis disposed of their former ace for three Cubs players and $150,000 in cash. Dean's comment at the time was, "I think I've just been traded from hamburger to steak." "Ol' Diz" was sore-armed and had lost his once-blazing fastball when the Cubs obtained him, but he was still a gate attraction. Although used sparingly, Dean won several key games during the 1938 pennant drive, winding up 7-1 with a sparkling 1.81 ERA.

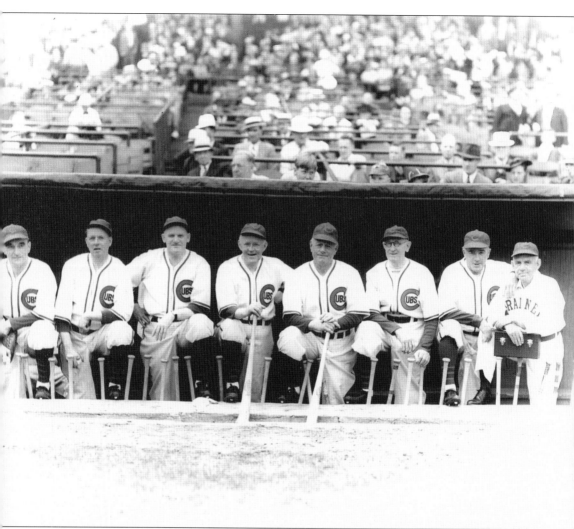

Cubs players of a bygone era pose in the Wrigley Field home dugout at an old-timers game on June 22, 1938. Pictured from left to right are Jimmy Archer, Mordecai "Three Finger" Brown, Ward Miller, Johnny Evers, Clarence Beaumont, ? McCartler, Joe Tinker, and a trainer by the name of Cahill. Who McCartler was remains a mystery, as his name does not appear in any baseball literature from any era.

FOUR

Gabby Hartnett and the End of the Glory Era
1938–1940

The Cubs were in fourth place with a 45-36 record on July 26, 1938, when Charlie Grimm voluntarily stepped down as manager. His successor was another fan favorite, catcher Gabby Hartnett. As had been the case six years earlier, changing horses in mid-stream worked.

If 1951 was the year of the "Miracle Giants," then 1938 was that of the "Miracle Cubs." The team began to gather momentum after the manager change, but by the stretch drive of mid-September they were still seven games behind the first-place Pirates. Suddenly, the Cubs began rattling off victory after victory as Pittsburgh's lead dwindled. By September 27 the lead was down to a game and a half when Dizzy Dean, obtained from the Cardinals in April, beat the Bucs 2-1 at Wrigley Field. The Cubs were now within a mere half game of the Pirates.

It was then time for the most celebrated event in Cubs lore. Darkness was encroaching Wrigley Field at 5:37 p.m. on September 28 in the bottom of the ninth, with the Cubs and Pirates tied at five runs each. With the sun going down, the umpires had already declared that there would be no further play after the ninth inning.

The Pirates had their ace fireman, Mace Brown, on the mound when Gabby Hartnett stepped to the plate with two out and nobody on base in a case of "now or never." On a no-ball two-strike count, Gabby belted Brown's next offering into the left-field bleachers for his famed "homer in the gloamin'" and a 6-5 Cubs victory. Now doing broadcast duties, Charlie Grimm was cheering from the radio booth.

By the time Hartnett reached second base, he was being mobbed by teammates, fans, ushers, vendors, and even Chicago policemen as pandemonium broke loose at the ballpark. The crowd wanted to carry the tomato-faced Irishman off the field, but plate umpire George Barr made sure Gabby touched all the bases plus home to make it official. And the paying crowd of 34,965 went home floating on air.

Contrary to popular belief, Hartnett's home run did not clinch the pennant for the Cubs—at least not technically. But for all practical purposes it did because Gabby had put his team in the

lead while destroying the Pirates' morale. The actual clincher came on October 1, 1938, with a 10-3 slaughter over the Cardinals at St. Louis. Under Hartnett's guidance, the Cubs went 44-27 to finish at 89-63.

Naturally, the seasoned catcher was not the only factor in the success of the ball club. Stan Hack had his best season yet, leading the pack with a .320 average, a career-high 195 hits, and 109 runs scored. Bill Lee assembled a league-leading 22-9 record with a 2.66 ERA and 9 shutouts. Four of those shutouts came in a row during September, tying a major league record set 30 years earlier by Cubs Mordecai Brown and Ed Reulbach. Second in command was Clay Bryant with 19 wins.

Returning to meet the Cubs in the World Series were Joe McCarthy and the Yankees. Once again, it was Marse Joe's vengeance. Babe Ruth had long since retired, but Lou Gehrig was still around and the Yanks had a young star in the person of Joe DiMaggio. As had been the case in 1932, they swept the Cubs in four straight—to the great surprise of nobody. The Cubs, who had hit only 65 home runs during the regular season, were simply no match for the power-laden Yankees. The sole Cubs pitcher who came even close to stopping them was Dizzy Dean, who in game two nursed a 3-2 lead with his "nothing ball" into the eighth inning at Wrigley Field. But two-run homers by Frank Crosetti and DiMaggio in the eighth and ninth turned the game into a 6-3 New York win.

All the Cubs could do was lick their wounds. On December 6, 1938, they traded Billy Jurges, Frank Demaree, and second-string catcher Ken O'Dea to the Giants for injury-prone outfielder Hank Leiber, shortstop Dick Bartell, and catcher Gus Mancuso.

For the most part, the deal did not work out well for the Cubs. Demaree hit over .300 for the Giants in 1939 and 1940, while Jurges anchored their infield for the next seven years. Leiber missed 42 games in 1939 because of injuries but between mishaps he was useful to the Cubs, leading the ball club with a .310 average, 24 home runs, and 88 RBIs. Bartell and Mancuso, however, were a different story. Both had been stars earlier in the decade, but by the time they reached Chicago they were thoroughly over their prime. Bartell batted a feeble .238 and was often booed because of his many errors at shortstop. The Cubs would be unable to fill Jurges's shoes until the arrival of Ernie Banks. Mancuso, as backup receiver to Hartnett, hit .231. Both were gone by the following season.

The acquisition of pitcher Claude Passeau from the Phillies in May 1939 helped offset the loss of sore-armed Clay Bryant, who won only two games. Passeau won 13 games for the Cubs and tied Bucky Walters of the Reds for the league-strikeout lead with 137. In addition to Bryant, Phil Cavarretta was sidelined with a broken leg, seeing action in only 22 games.

The final two months of the campaign saw the arrival of outfielder Bill Nicholson, who became the Cubs' best home-run hitter throughout the 1940s. Despite all the injuries, the team finished a respectable fourth.

By 1940 Gabby Hartnett, now approaching age 40, was mainly a bench manager as he appeared in only 37 games, many of them as a pinch hitter. Bill Lee, beginning to experience eye problems, fell to 9-17 and would never regain his former effectiveness. The Cubs were also weak at the shortstop and catcher positions, and injuries continued to plague the team. On the plus side, Claude Passeau came in as the new ace with a 20-13 log and a 2.50 ERA. Stan Hack had the team's top batting average with .317 as his 191 hits led the league. Nicholson, in his first complete season, batted .297 with club-high 25 home runs and 98 RBIs.

But the Cubs dropped to fifth place with a 75-79 record for their first losing season in 15 years. When Hartnett was fired as manager in November 1940, it symbolized the end of an era. Leaner times were to follow.

This picture of Cubs outfielder and first-baseman Phil Cavarretta was taken sometime in the late 1930s. His 20 years as a Cubs player are exceeded only by Cap Anson. He ended his career with the White Sox in 1955, and retired as a .293 lifetime hitter with 1,977 hits. He won the batting title and MVP Award in 1945 when his league-leading .355 average helped the Cubs win their last flag to date, and later served as Cubs player-manager from 1951 to 1953.

Catcher Charles "Gabby" Harnett is seen here roughly halfway through his Cubs career, which began in 1922 and ended in 1940. By far the greatest receiver in a Cubs jersey, Hartnett was no slouch as a hitter either. He batted over .300 five times, including .354 in 1937, the year of his 26-game hitting streak. Gabby had considerable power as well, clubbing 24 home runs in 1925, 37 in 1930, and 22 in 1934. With his magnet glove, he topped National League catchers in fielding percentage six times. By the time he was appointed manager in 1938, Hartnett was declining as a player and was released in 1940. He played for the Giants in 1941 before retiring with a .297 career batting average, 1,912 hits, and 236 home runs. His 231 homers as a Cub were a club record until broken by Ernie Banks. Hartnett was elected to the Hall of Fame in 1955.

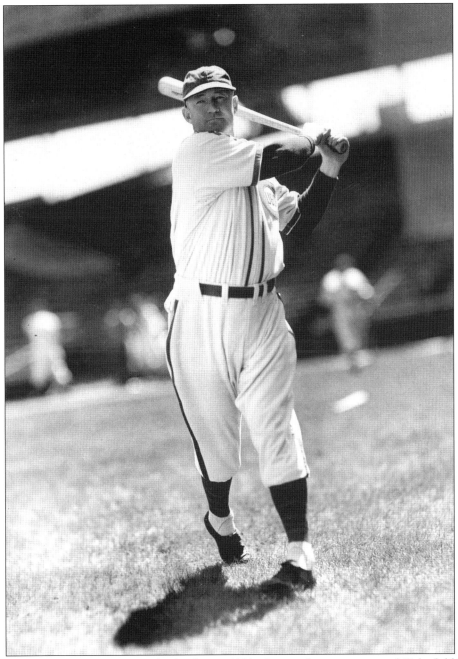

An old Gabby Hartnett swings the lumber in 1938, the year he was appointed Cubs field boss in mid-season.

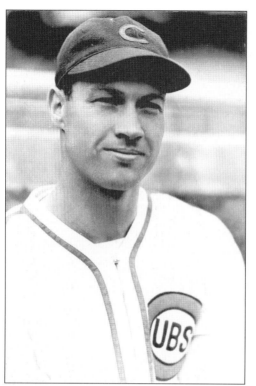

Pitcher Clay Bryant broke in with the Cubs in 1935, and by 1938 had blossomed into their number-two winner with a 19-11 mark and a league-best 135 strikeouts. His pitching days ended two years later because of arm problems.

Augie Galan smiles for the camera from the steps to the Cubs dugout at Wrigley Field in 1938.

The Cubs' two Billies—Herman and
Jurges—survey the field from the home
dugout in 1938.

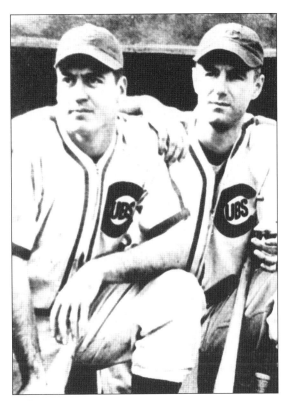

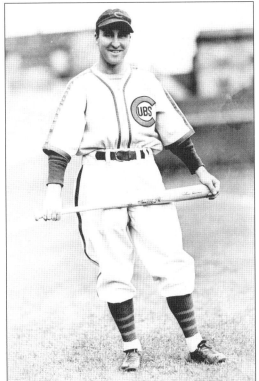

First baseman James "Rip" Collins poses
in 1938, his last of two seasons with the
Cubs. In his earlier years as a member of the
"Gashouse Gang" Cardinals, Collins enjoyed
some productivity at the plate, but his
accomplishments as a Cub were minimal.

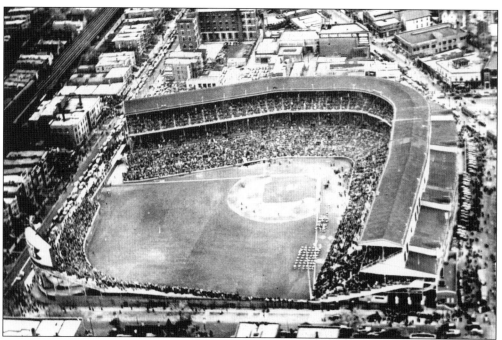

Here is an aerial view of Wrigley Field during the 1938 World Series with the Yankees. The picture tells it all.

Outfielder Hank Leiber, shown here in 1939, came to the Cubs the previous winter in the deal that sent Billy Jurges to the Giants. Leiber, whose major-league stay was cut short by injuries, had two good seasons as a Cub. He batted .310 with 24 home runs and 88 RBIs in 1939 and followed that up with .302/17/86 marks the following year. But when Hank slumped in 1941, he was released and sent back to the Giants.

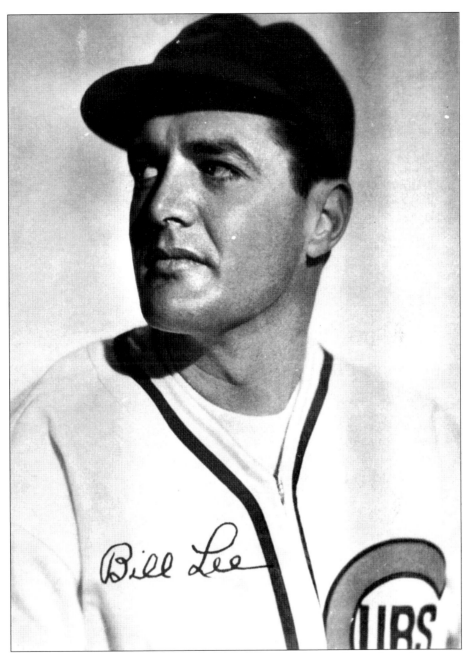

Bill Lee was among the top Cubs pitchers of the 1930s, and their undisputed number-one starter after Lon Warneke was traded. Following two relief appearances, Lee hurled a four-hit whitewash of the Phillies at Wrigley Field on May 7, 1934. He finished that season at 13-14, not bad for a rookie. He then led the team to two pennants with a 20-6 showing in 1935 and 22-9 in 1938. By 1940, Bill began to suffer visual difficulties which would eventually lead to blindness, and his record fell to 9-17. He made a semi-comeback in 1942, going 13-13, but the magic of the 1930s would never return. Traded to the Phillies in August 1943, Lee bounced to the Braves before returning to the Cubs on waivers in 1947. He retired after that season with a lifetime 169-157 record.

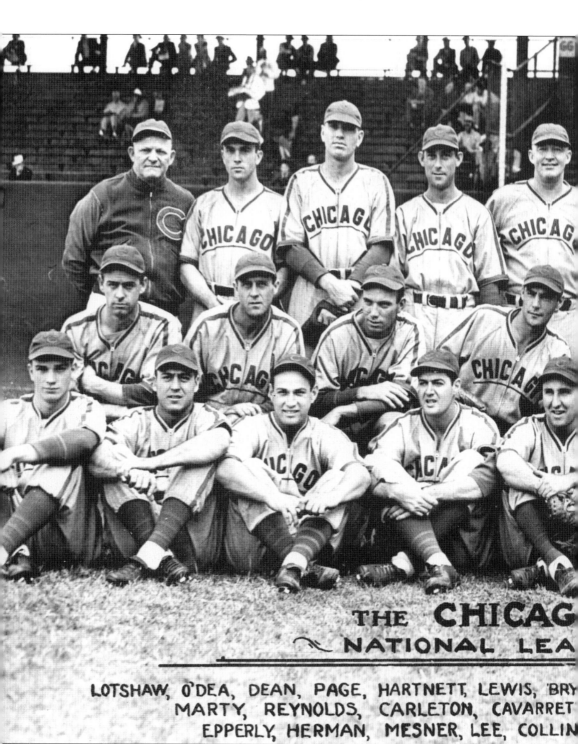

THE **CHICAG**

NATIONAL LEA

LOTSHAW, O'DEA, DEAN, PAGE, HARTNETT, LEWIS, BRY
MARTY, REYNOLDS, CARLETON, CAVARRET
EPPERLY, HERMAN, MESNER, LEE, COLLIN

The 1938 Cubs are seen here in their road uniforms. In which ballpark the photograph was taken is unknown. Gabby Hartnett (top row, fifth from left) replaced Charlie Grimm as manager on July 20, when the Cubs were in fourth place with a 45-36 mark. Under Hartnett's command, they rallied for a 44-27 log to cop the flag by two games over the Pirates. It was Gabby's "Homer in

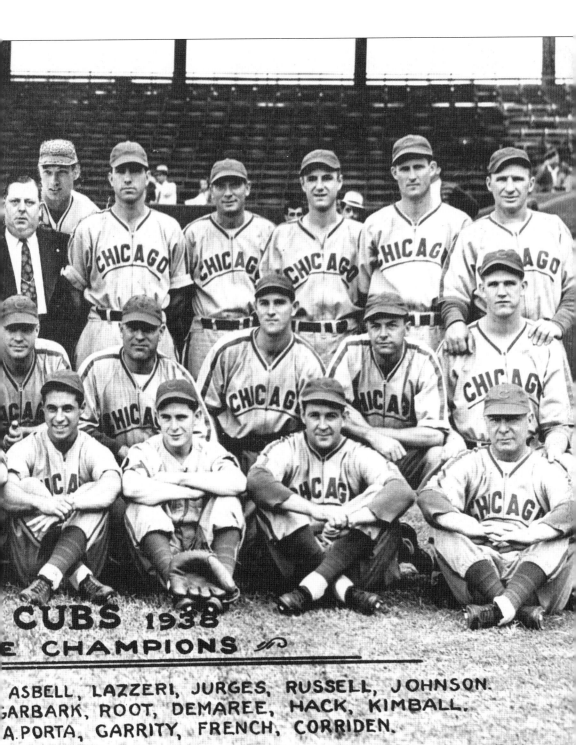

CUBS 1938
E CHAMPIONS

ASBELL, LAZZERI, JURGES, RUSSELL, JOHNSON.
GARBARK, ROOT, DEMAREE, HACK, KIMBALL.
A. PORTA, GARRITY, FRENCH, CORRIDEN.

the Gloamin'" off Pittsburgh's Mace Brown in the bottom of the ninth on September 28, 1938, at Wrigley Field that put the Cubs in first place to stay with a 6-5 victory. They clinched the pennant three days later with a 10-3 blasting of the Cardinals at St. Louis.

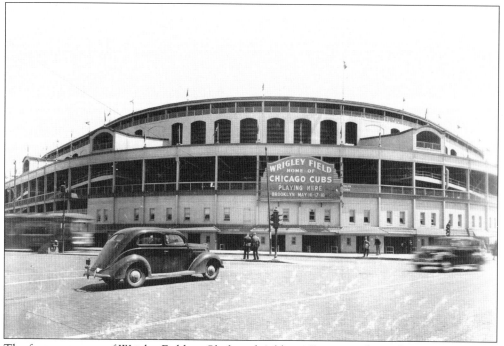

The front entrance of Wrigley Field, at Clark and Addison Streets, is shown here on a quiet day in the late 1930s.

Joe Marty was a second-string Cubs outfielder in the late 1930s. His brief career was unremarkable except for his role as a hero in a losing cause during the 1938 World Series against the Yankees. He batted .500 with a home run and five RBIs.

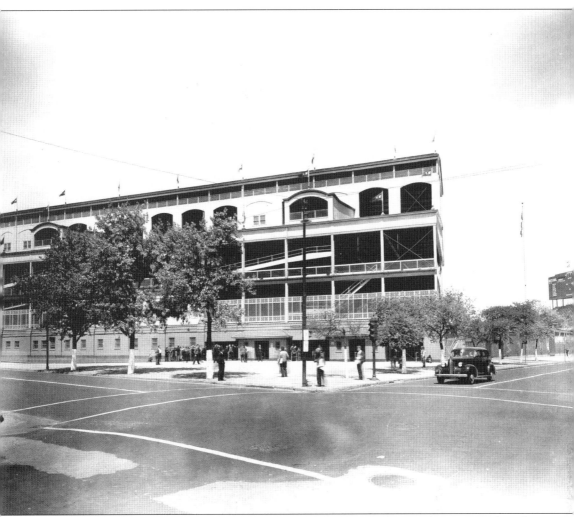

The southeast corner of Wrigley Field is captured in the summer of 1938. The new scoreboard had just been installed and did not yet have a clock.

CUBS — CARDS IN HOME OPENER

TRIPLETT IS PUTTING UP GREAT FIGHT

Has Speed and Punch

Herman Coaker Triplett, the Southern Association outfield star who came to the Cubs this spring, is putting up a great fight to stick with the club this season. Triplett has been looking better in every game, both in the field and at bat.

Manager Grimm likes the youngster and is giving him every opportunity, seeing in the Southern boy the possibilities of a fine outfielder. Triplett has been playing the sun field during the spring exhibition games and handles the job like a veteran.

When the Cubs opened their training at Santa Catalina Island big Jim Asbell, also secured from the Southern Association, looked like a cinch for an outfield berth, but Triplett has been giving Jim a real battle the past few weeks and it looks like Grimm may have a problem deciding between the two.

Triplett

"Speedball" Bryant!

MEDWICK, MIZE, WARNEKE, DEAN, INVADE CHICAGO

Series April 22, 23, 24

The Chicago Cubs and St. Louis Cardinals will "kick-off" the baseball lid of the 1938 National League season at Wrigley Field on Friday, April 22. The Cardinal series will include Saturday and Sunday, April 23 and 24.

Manager Charlie Grimm, of the Cubs, has not decided upon his pitcher for the opening game here, as the Cubs open the season on April 19, in Cincinnati, where they play a three-game series with the "Reds." The Cubs' pitching staff is in good condition and every man ready for the call.

Manager Frankie Frisch is anxious to get the jump on the Cubs early in the season as this is the team he figures the 'gas House Gang" will have to beat to finish at the top of the National League heap. It is almost a certainty that Dean and Warneke will see action during the three games here.

Frisch's crew still pack plenty of dynamite at the plate and this spring "Pepper" Martin has served notice that this is going to be one of his big years.

Warneke

Tickets for the opening game are now on sale at Wrigley Field and all Western Union offices in Chicago. The Friday game will start at 3 p. m., Saturday's game at 2 p. m., and on Sunday at 3 p. m.

BRYANT LOOKS GREAT!

Clay Bryant, the Cubs' big right handed "speedball" pitcher, has made a very impressive showing in the exhibition games this spring. In fact Bryant's performance has been so good he may draw the opening day pitching assignment against the Reds in Cincinnati on April 19.

CUBS' HOME GAMES

April 22 (Opening Game)	St. Louis
April 23	St. Louis
April 24	St. Louis
April 28	Cincinnati
April 29	Cincinnati
MAY	
May 3	Philadelphia
May 4	Philadelphia
May 5	Philadelphia
May 6	Boston
May 7	Boston
May 8	New York
May 9	New York
May 10	New York
May 11	Brooklyn
May 12	Brooklyn
May 13	Pittsburgh
May 14	Pittsburgh
May 15	Pittsburgh
May 30 (Double-header)	Cincinnati

The *Chicago Cubs News* kept Chicago fans abreast of the on-the-field and clubhouse goings-on of their favorite ball club during the baseball season.

Bob
Garbark
Cubs'
promising
young
catcher

CHICAGO CUBS
NEWS

John
McCarthy
Giants'
star
first
baseman

VOLUME 3, NO. 4 **WRIGLEY FIELD, MAY 30, 1938** **CHICAGO, ILLINOIS**

CUBS RETURN FOR 15 HOME GAMES

BOSTON "BEES" GOING GREAT FOR STENGEL

Here June 1, 2, 3

Casey Stengel and his Boston "Bees," who invade Wrigley Field for a three-game series June 1, 2, and 3, have been displaying the brand of baseball Boston fans believe will land them in the first division this year.

Recently Southpaw Milt Shoffner held the heavy hitting Pittsburgh Pirates to three hits, while his teammates earned him a 1-0 victory over Russ Bauer's one-hit pitching. The "Bees" have in Catcher Mueller a young receiver who many believe is destined to become one of the greatest catchers in the league. A fine receiver with a strong arm, Mueller has speed and plenty of power at the plate.

The last time Pittsburgh was in Boston the "Bees" stopped them cold, winning three thrilling games, two in extra innings. The second game was the longest of the season, fourteen innings. In this series the "Bee" hurlers uncorked some brilliant pitching.

The final game of this series will be Ladies' Day. All games will start at 3 p. m., and tickets are now on sale at Wrigley Field and all Western Union offices in Chicago.

Mueller

CUBS' HOME GAMES

May 30 (Double Header)	Cincinnati
June 1	Boston
June 2	Boston
June 3 (Ladies' Day)	Boston
June 4	Philadelphia
June 5	Philadelphia
June 6	Philadelphia
June 7	New York
June 8 (Double Header)	New York
June 9	New York
June 10 (Ladies' Day)	Brooklyn
June 11	Brooklyn
June 12	Brooklyn

A "Steady Guy"!

"CINCY" REDS HERE FOR TWO GAMES MAY 30

Eastern Teams Coming

The Cubs open a 15-game home stay at Wrigley Field on Decoration Day, when they meet the Cincinnati Reds in a holiday double-header, starting at 1:30 p. m.

During the Cubs' home stay they will meet all the eastern clubs, Boston, Philadelphia, New York and Brooklyn. Manager Charlie Grimm is looking forward to this sojourn at Wrigley Field as he believes the club will start going places in the pennant race.

"We're beginning to get a few breaks for ourselves and should gain some ground on this home stay," said Grimm. "The pitching looks better, our defense is tops and I think our hitters are improving, though we have a mighty good team batting average right now."

Derringer

Reds Tough

Big Paul Derringer, who has been going in top form for the Reds, may see action in the twin bill Decoration Day. Manager McKechnie has the boys from Rhineland hustling and playing heads-up baseball, so the Cubs will not start their home stay with an easy hurdle.

The Reds have been a consistent stumbling block for the Giants this season, capturing two out of three games in Cincinnati and winning two straight in New York.

Tickets for the double-header and all Cub home games are now on sale at Wrigley Field and all Western Union offices in Chicago.

HACK HITTIN' HARD!

Stanley Hack, the Cubs' star third sacker, has been playing one of the steadiest games of his brilliant career this season, and hammering the ball at a .339 clip. Stanley hit consecutively in the first 15 games; was stopped on May 4, and then started another streak. Stanley is recognized as the best third baseman in baseball.

As the Cubs began to set their sites on the 1938 National League pennant, this May 30 issue of the *Chicago Cubs News* touted the club's "Stanley" Hack as the "best third baseman in baseball."

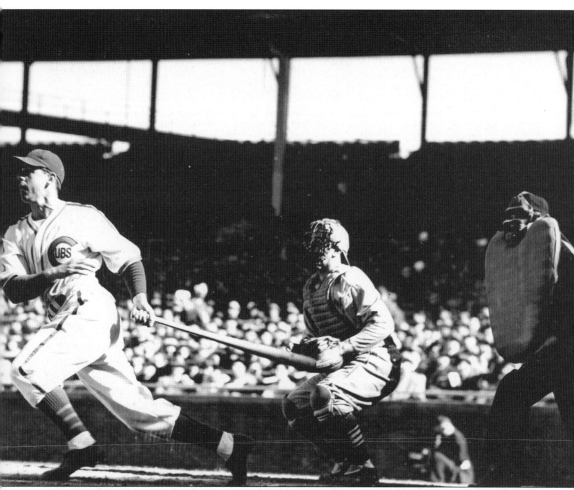

At this 1938 Cubs-Cardinals contest at Wrigley, Joe Marty is the Cubs batter, Mickey Owen is the Cardinals catcher, and Beans Reardon is the plate umpire.

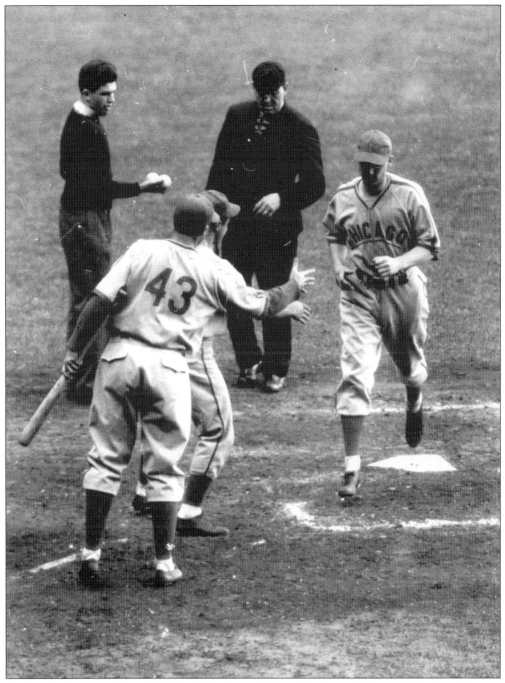

In the third game of the 1938 World Series at Yankee Stadium, Cubs outfielder Joe Marty is congratulated by teammate Carl Reynolds and the Cubs' bat boy after hitting a home run. New York won the game 5-2 and the Series in four games straight.

These programs from 1938 (left) and 1939 (celebrating baseball's "Centennial") are from Wrigley Field ball games versus the Pirates and Braves, respectively. They still cost only 10¢.

This back-cover advertisement for Pabst Blue Ribbon clearly indicates the post-Prohibition era at the ballpark. A ice-cold can of beer cost only 20¢ at Wrigley at the time, and to that could be added a couple of red hots and bag of candy—all for another quarter.

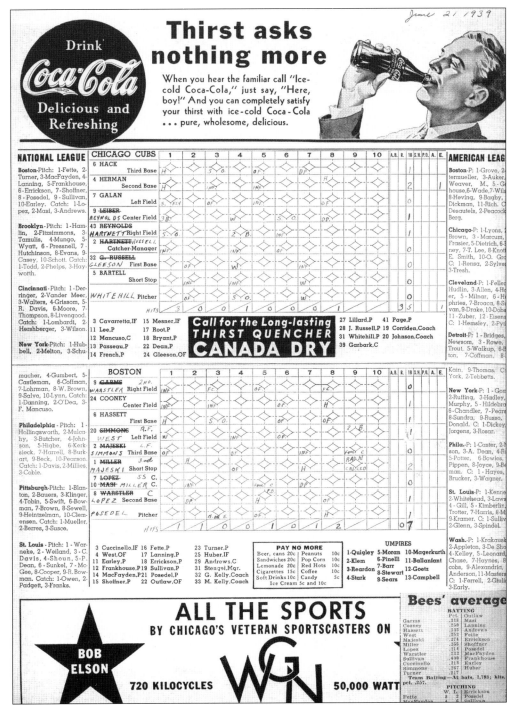

According to this completed box score, the Cubs got the best of the Braves 3–0 in this June 21, 1939, contest at Wrigley Field. The scorekeeper must have been keeping an eye on the competition, as a clipping with Boston's season averages is pasted on the lower right-hand corner.

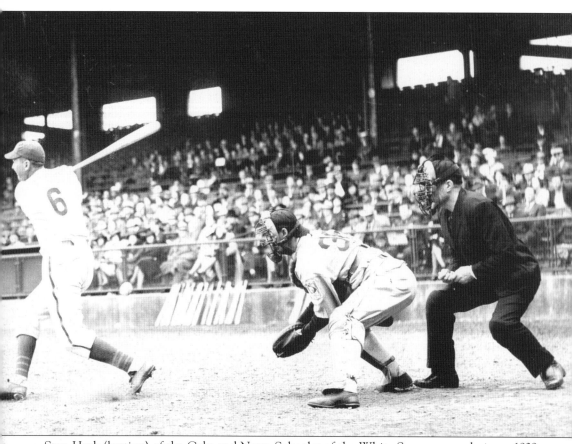

Stan Hack (batting) of the Cubs and Norm Scleutler of the White Sox are seen during a 1939 spring exhibition game at Wrigley Field in Los Angeles. At the time, the old Los Angeles Angels of the Pacific Coast League were a Cubs farm team, hence the ballpark's name.

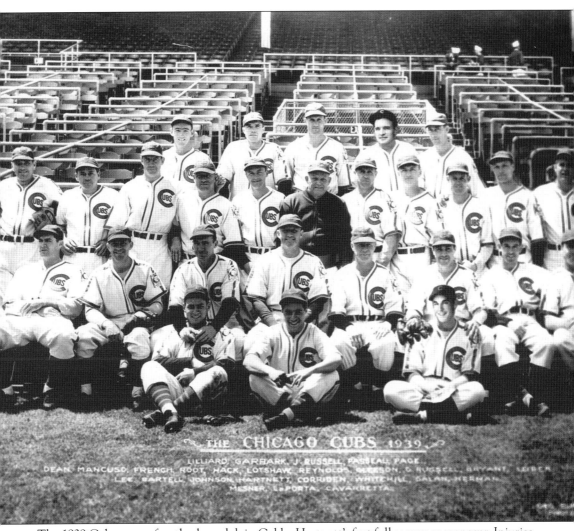

THE CHICAGO CUBS 1939

LILLARD, GARBARK, J. RUSSELL, PASSEAU, PAGE.
DEAN, MANCUSO, FRENCH, ROOT, HACK, LOTSHAW, REYNOLDS, GLEESON, C. RUSSELL, BRYANT, LEIBER
LEE, BARTELL, JOHNSON, HARTNETT, CORRIDEN, WHITEHILL, GALAN, HERMAN
MESNER, LaPORTA, CAVARRETTA

The 1939 Cubs were a fourth-place club in Gabby Hartnett's first full season as manager. Injuries and the lack of a good shortstop prevented a higher finish. The season was notable for the arrival of two future stars—pitcher Claude Passeau and outfielder Bill Nicholson.

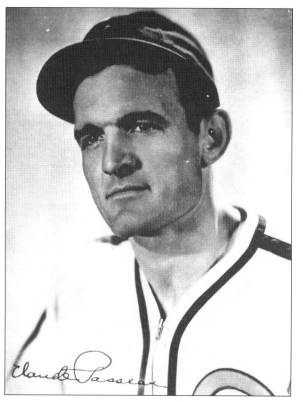

Pitcher Claude Passeau is pictured here in 1939, which was his first year with the Cubs after being obtained in a trade with the Phillies. The ace of the Cubs staff throughout the early and mid-1940s, Passeau won 20 games in 1940, 19 in 1942, and 17 in 1945. He hurled a one-hit shutout over the Tigers in the 1945 World Series and retired two years later with a 162-150 record.

Outfielder Bill Nicholson is seen here early in his days with the Cubs. A Cub from 1939 through 1948, Nicholson was their number-one slugger of the decade as well as a good defensive outfielder. Bill was draft-exempt due to color blindness, and he topped the league in home runs and RBIs in 1943 and 1944.

CHICAGO CUBS NEWS

VOLUME 4, NO. 4 **WRIGLEY FIELD, JUNE 12, 1939** **CHICAGO, ILLINOIS**

N. Y. GIANTS INVADE WRIGLEY FIELD

THOSE DODGERS "RIDE AGAIN"— AND, TO CHICAGO

Here June 17, 18, 19

They may be the "Daffy Dodgers" to some teams but to Manager "Gabby" Hartnett and the champion Cubs, the boys from Flatbush are just a "pain in the neck."

Manager Leo Durocher leads his Brooklyn clan

into Wrigley Field for a four games series, June 17, 18 and 19 and local Cub fandom is gathering up tents and provisions to camp out at Wrigley Field until the issue is settled.

On Sunday, June 18, the Cubs and Dodgers will try and settle their 19-inning tie game of May 17, with a double-header and if this twin bill takes as long as the 19-inning tie game and the recent 14-inning night game in Brooklyn, Cub fans will be prepared to stick it out till the finish.

Koy

Tickets for series now on sale at Wrigley Field and Western Union offices in Chicago.

CUBS' HOME GAMES

June 14	New York
June 15	New York
June 16 (Ladies' Day)	New York
June 17	Brooklyn
June 18 (Double-Header)	Brooklyn
June 19	Brooklyn
June 20	Boston
June 21	Boston
June 22	Boston
June 23 (Ladies' Day)	Philadelphia
June 24	Philadelphia
June 25	Philadelphia

Dean Is Ready!

CUBS MEET EAST IN 13 HOME TILTS

N. Y. Series June 14, 15, 16

The Chicago Cubs return to Wrigley Field on June 14 to meet the New York Giants in a three-game series, the first of a 13-game home stay, during which all the eastern clubs will pay a visit to Chicago.

The Giants, like the Cubs, have experienced considerable difficulty in starting to "click" and as a result are occupying an unfamiliar position in the league standing. Manager Bill Terry is credited with the statement, as the present season got under way, that this year's Giants were the greatest team he had ever managed.

There are a great many Giant fans who share Terry's opinion and still believe the boys from Coogan's Bluff will be leading the National League pack in October.

Among Terry's old reliables carrying on as usual are Joe Moore and Mel Ott. These two brilliant outfielders are still causing plenty of trouble for the pitchers in the senior circuit. Ott, long a nemesis to Larry French of the Cubs, failed on his last trip to Chicago to cause much worry to either French or the Cubs. The Cubs' star southpaw is hoping the Ott spell has been broken.

Mel Ott

Tickets for this series are now on sale at Wrigley Field and all Western Union offices in Chicago.

"DIZZY" COMES BACK!

Forty-seven thousand loyal Cub and "Dizzy" Dean fans, who watched his brilliant 4-0 triumph over Boston and his 6-2 win over Pittsburgh, are agreed today that ol' Diz again has confounded his critics, who said he'd "never pitch again," and is ready to take his regular turn on the mound.

This June 12, 1939, *Chicago Cubs News* lauds the readiness of future hall of famer Dizzy Dean to reestablish himself as an ace on the mound.

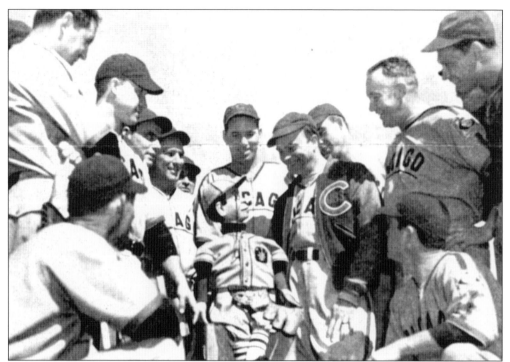

Charlie McCarthy, who suited up to work out with the 1938 pennant winners during 1939 spring training on Catalina Island, clowns around with a ventriloquist-and-puppet act: "Mow 'Em Down Boys," reads the caption in *Cubs News*, " . . . you're gonna mow 'em down I tell you." Ventriloquist Edgar Bergen was a native Chicagoan who grew up near Wrigley Field.

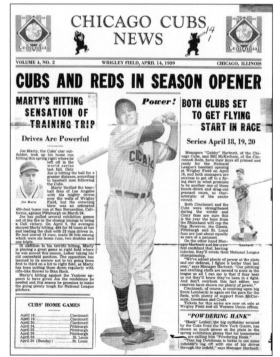

Here's the Opening Day issue of *Chicago Cubs News*, featuring outfield slugger "Powdering Hank" Leiber.

Jimmy Gleeson batted .313 as the Cubs' regular left fielder in 1940. It was his only good season in an otherwise undistinguished stay in baseball.

Here is a close profile of Cubs third-baseman Stan Hack with his autograph, around 1940.

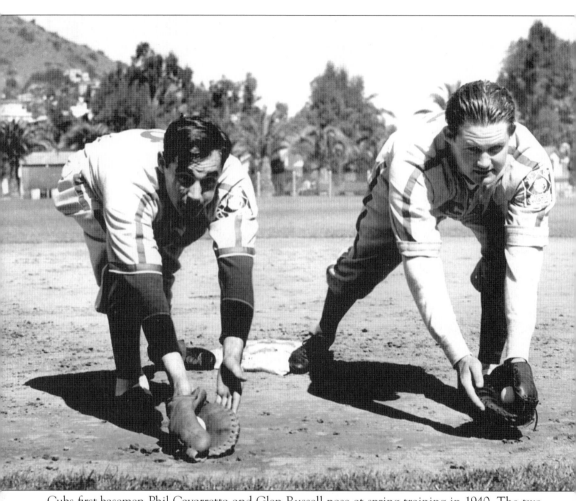

Cubs first-basemen Phil Cavarretta and Glen Russell pose at spring training in 1940. The two split the job that season, as both spent time on the disabled list.

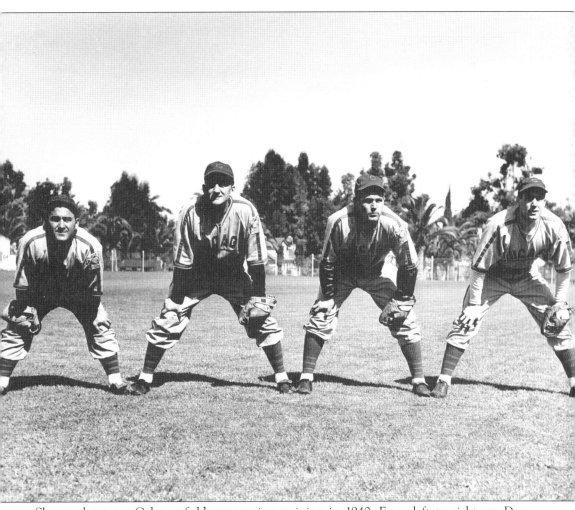
Shown above are Cubs outfielders at spring training in 1940. From left to right are Dom Dallessandro, Jimmy Gleeson, Bill Nicholson, and Barney Olsen.

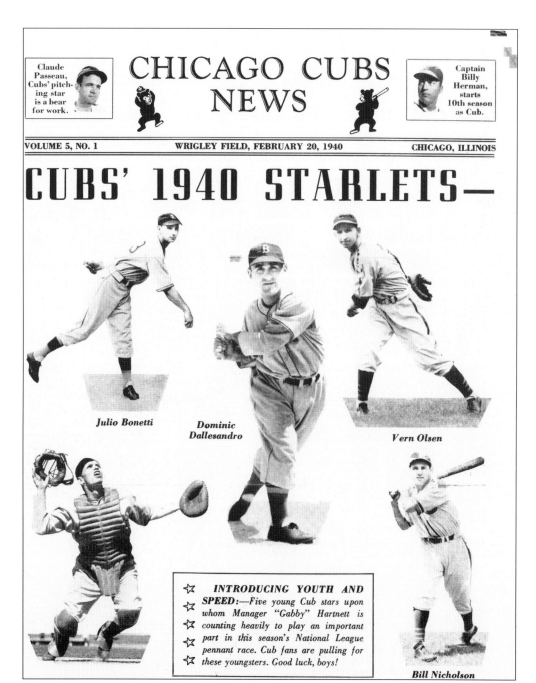

Claude Passeau, Cubs' pitching star is a bear for work.

CHICAGO CUBS NEWS

Captain Billy Herman, starts 10th season as Cub.

VOLUME 5, NO. 1 WRIGLEY FIELD, FEBRUARY 20, 1940 CHICAGO, ILLINOIS

CUBS' 1940 STARLETS—

Julio Bonetti

Dominic Dallesandro

Vern Olsen

☆ **INTRODUCING YOUTH AND SPEED:**—*Five young Cub stars upon whom Manager "Gabby" Hartnett is counting heavily to play an important part in this season's National League pennant race. Cub fans are pulling for these youngsters. Good luck, boys!*

Bill Nicholson

Even in the middle of winter, Chicago baseball fans could read up on Cubs prospects for the coming season. This February 20, 1940, issue of *Chicago Cubs News* harkens the arrival of "Youth and Speed" to Wrigley Field.

 Ernie Lombardi, "Cincy Reds" batting star.

 Johnny Mize is Cardinals' "power-house."

CHICAGO CUBS NEWS

VOLUME 5, NO. 5 WRIGLEY FIELD, AUGUST 12, 1940 CHICAGO, ILLINOIS

CARDS OPEN CUBS' HOME STAY

BONURA FANS HAPPY; ZEKE JOINS CUBS

"I'm Happy, Too," Zeke

Chicago's baseball fandom from the north, south and west are planning an armistice in baseball's civic warfare on August 12 to journey to Wrigley Field and welcome back to Chicago their old friend and idol, Zeke Bonura.

Zeke, long a popular and colorful figure in Chicago, was purchased from the Washington Senators to take over the Cubs' first base job when an operation and an injury laid low both Glenn Russell and Phil Cavarretta.

"Chicago is my second home," said Bonura upon joining the Cubs, "and I'm certainly happy to be back among my old baseball friends."

In his anxiousness to make good in a Cub uniform, the New Orleans banana king started pressing with the result Manager Hartnett decided to return Hank Leiber to first base and give Big Zeke a little time to relax.

However, regardless of Zeke's achievements on the road, when the Cubs return to Wrigley Field for their long home stay, ol' Zeke's Chicago well wishers will be on hand to greet the big first sacker.

 Zeke Bonura

CUBS' HOME GAMES

August 12, 13	St. Louis
August 14, 15	Cincinnati
August 16 (Ladies' Day)	Cincinnati
August 17, 18	Pittsburgh
August 20, 21	Philadelphia
August 22	Brooklyn
August 23 (Ladies' Day)	Brooklyn
August 24	Brooklyn
August 25 (Double-Header)	New York
August 26, 27	New York
August 28, 29	Boston

"Ice Water!"

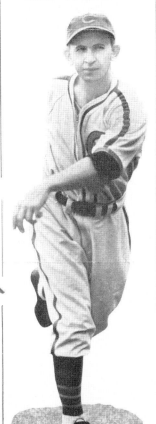

HARTNETT'S CREW HOPE TO CLIMB IN 18-GAME STAY

First Series August 12, 13

The St. Louis Cardinals, who a majority of the experts predicted last spring were the team to beat in this year's National League race and who recently started to show their power, will invade Wrigley Field for a two-game series with the returning Cubs on August 12 and 13.

The Cubs will be home for an 18-game stay, during which time they hope to improve their position in the pennant race. They will meet every team in the league in this home stand, and north side fans are pulling for a few breaks and a sustained winning streak.

 Warneke

Despite illnesses and injuries which have harassed the Cubs, Manager Hartnett is hopeful of assembling enough able bodied men to stage a typical Cubs' late season drive and close in on the leaders.

"I think my gang is going to blast some pennant hopes," Manager Billy Southworth, of the Cardinals, said recently. "We're getting some pretty good pitching now, and Mize and Slaughter and the rest of the boys are teeing off on the ball. We should go from now on in."

Lon Warneke, an old Cub favorite, is likely to face the Cubs in one of the games, as he's usually very effective against his old

Slaughter

mates in Wrigley Field. Tickets for this series are now on sale at Wrigley Field and all Western Union offices in Chicago.

A STAR IS BORN!

So cool and undisturbed is Vern Olsen, Cubs' young southpaw mound star, opposing batters say he has "ice water" in his veins.

Since joining the Cubs last fall, Vern has cooled off the National League's most torrid sluggers. He gives promise of many years of stardom in a Cubs' uniform.

Chicago Cubs News on August 12, 1940, looked forward to a productive 18-game Wrigley Field home stand against the Cubs' National League rivals.

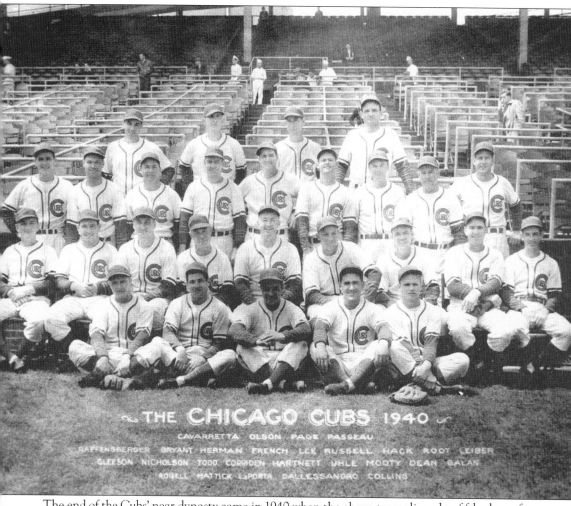

~ THE CHICAGO CUBS 1940 ~
CAVARRETTA OLSON PAGE PASSEAU
RAFFENSBERGER BRYANT HERMAN FRENCH LEE RUSSELL HACK ROOT LEIBER
GLEESON NICHOLSON TODD CORRIDEN HARTNETT UHLE MOOTY DEAN GALAN
ROGELL MATTICK LaPORTA DALLESSANDRO COLLINS

The end of the Cubs' near-dynasty came in 1940 when the above team slipped to fifth place after 14 straight seasons in the first division. Sadly, worse times were to follow.

Epilogue
Decline and War Years

During the winter of 1940–1941, Phillip K. Wrigley hired Jimmy Wilson, a retired catcher, to replace Gabby Hartnett as field boss and sportswriter James Gallagher as the Cubs' first general manager. Together, the "James Boys" embarked on a series of trades that made the Cubs look like a farm team for the Dodgers.

Jealous of Billy Herman's overwhelming popularity, Wilson talked Gallagher into swapping the great second baseman to Brooklyn for outfielder Charlie Gilbert, infielder Johnny Hudson, and $40,000 cash early in the 1941 season. Lou Stringer, Herman's replacement at the Keystone sack, could not hold a candle to Billy Herman. Later in the season, Augie Galan and Larry French were also dealt to the Lords of Flatbush. Thought to be washed up, they both discovered the fountain of youth in their new uniforms.

The result? The Dodgers won their first pennant in 21 years and the Cubs sank to sixth place as weaknesses, which were visible the previous season, grew increasingly glaring. Pitching and defense were on the decline, and hitting was inconsistent. While the Dodgers and Cardinals had built massive farm systems, the Cubs lagged behind in that area as the younger Wrigley's incompetence as an owner was becoming evident. Their most touted rookie, outfielder Lou Novikoff, batted .241 in 70 games before being sent back to Los Angeles for more seasoning.

At the tail-end of the season, the Cubs' front office announced that the team would be having some night games beginning in 1942. However, following the Japanese attack on Pearl Harbor, Wrigley donated the light poles to the government as scrap metal for the war effort. By the time World War II was over, Wrigley had changed his mind concerning night baseball and the park would remain without lights until 1988.

Pearl Harbor affected more than night baseball at Wrigley Field, as the big leagues heard the call from Uncle Sam. While the 1942 season was almost up to pre-war standards, the quality of baseball dropped like a falling star thereafter. With most of the real talent being gobbled up by the military, major league rosters brimmed with fuzzy-faced teenagers, Triple-A lifers, and aging has-beens who were too old to be drafted.

For the Cubs, it was a time when such legendary (if not overly successful) characters as Lennie Merullo, Dom Dallessandro, Hiram Bithorn, Paul Erickson, Heinz Becker, and the aforementioned Lou Novikoff flourished. While the period was more memorable for laughs than victories, the story about the fly ball bouncing off Novikoff's head is purely apocryphal.

Weak up the middle and with few quality pitchers, the Cubs repeated their sixth-place finish in 1942. Fans could look with pride only to the steady play of Stan Hack and husky catcher Clyde McCullough; the slugging of Bill Nicholson; the pitching of Claude Passeau; and the hustling of Phil Cavarretta, who had been recycled at first base after several years as a utility player. Outfielder Harry "Peanuts" Lowrey and pitcher Hank Wyse were given brief trails.

History was made in a bizarre way on September 13, 1942, when Cubs shortstop Lennie Merullo committed four errors in the second inning during a game against the Braves at Boston. Lou Novikoff muffed two fly balls himself during the game, but the Cubs miraculously held on to win

12-8. More significantly, it was the major-league debut of Boston left-hander Warren Spahn, who went on to win 363 games.

The following year, the Cubs inched up to fifth place as Novikoff staged a holdout, and Cavarretta and Nicholson approached their prime. Lowrey looked good in the outfield, Wyse worked his way into the rotation, and rookie Eddy Stanky showed promise at second base. However, when the Cubs brought up Don Johnson late in the year, they soured on Stanky too soon. The following June he was traded to Brooklyn for pitcher Bob Chipman. During the off-season, Cubs fans were given a jolt when Stan Hack announced his retirement rather than play another year under Jimmy Wilson.

In 1944, the Cubs got off to their worst start yet, losing 13 in a row after winning the opener. Jimmy Wilson's head rolled and in his place retuned the familiar face of Charlie Grimm. (Coach Roy Johnson served as interim manager for one game.) Upon assuming his second tour of duty as Cubs manager, Grimm coaxed Stan Hack out of retirement. Since they were good friends, it did not take much persuasion.

That having been accomplished, the Cubs steadily recuperated, eventually ending the season in fourth place. At second base, Don Johnson lived up to expectations, as did young center fielder Andy Pafko, who had also joined the team late in 1943. With Pafko, Nicholson, and Dom Dallessandro as the regular outfielders (Lowrey was in the service but would return the following year), the erratic Novikoff was used sparingly and released at the end of the season.

During the spring of 1945, most writers saw the Cubs finishing at best second behind the Cardinals, who had just won three straight pennants along with the 1942 and 1944 World Series. When the Cubs began sluggishly, it looked as if the scribes might be right. Nevertheless, Chicago began to gain ground, capturing the lead on July 8 in the midst of an 11-game winning streak. St. Louis provided stiff competition, and perhaps an added incentive.

On July 27, 1945, Jim Gallagher pulled a genuine steal by obtaining pitcher Hank Borowy on waivers from the Yankees. In spite of recurrent blisters on his pitching hand, Borowy proved to be an elixir. Winning 11 of 13 decisions, he was the only Cubs hurler who was effective against the Cardinals.

The Cubs nailed down the pennant with a 4-3 victory at Pittsburgh on September 29, with St. Louis just three games behind. Winning the Most Valuable Player Award, Cavarretta batted .355 to lead the league. Pafko, Lowrey, Hack, and Johnson also enjoyed excellent years at the plate. Wyse won 22 games and Passeau 17. Two aging hurlers, Paul Derringer and Ray Prim, provided unexpected heroics.

Cynics claimed—and still do—that the Cubs won the 1945 flag only because they had more 4-Fs (a military classification for a person who is unfit for military service) than any other team in the league. Although somewhat magnified, this criticism is not without merit. The Cardinals, for example, had just lost Stan Musial to the Navy, and he likely would have made the difference.

In the World Series, the Cubs met the Tigers for the fourth time. The Series went the full seven games before Chicago finally succumbed, their best showing since last winning it (also against Detroit) in 1908. Cub highlights included Passeau's one-hit shutout in game three and Stan Hack's clutch double in the bottom of the 12th inning to win game six.

But the joy would soon pass. While the Cubs had a good lineup by wartime standards, these standards were not nearly as high as during peacetime. Furthermore, the Cubs had not been hurt by the draft as badly as most other teams, but in 1946 this temporary advantage disappeared quickly. Also, many of their stars were aging players for whom 1945 had been essentially a last hurrah. In this category were Hack, Johnson, Derringer, Passeau, Prim, and infielder Roy Hughes. Of the entire roster, the only player with his best years looking forward was Andy Pafko. Unable to content against tougher rivals, the defending National League champs tumbled to a distant third.

Then came Armageddon as the Cubs languished in the second division from 1947 through 1966 with just two seasons at .500 or better—and only barely at that (77-77 in 1952 and 82-80 in 1963). Not until the Leo Durocher era of the late 1960s and early 1970s would the Cubs again be a contender. That, however, is a story in itself.

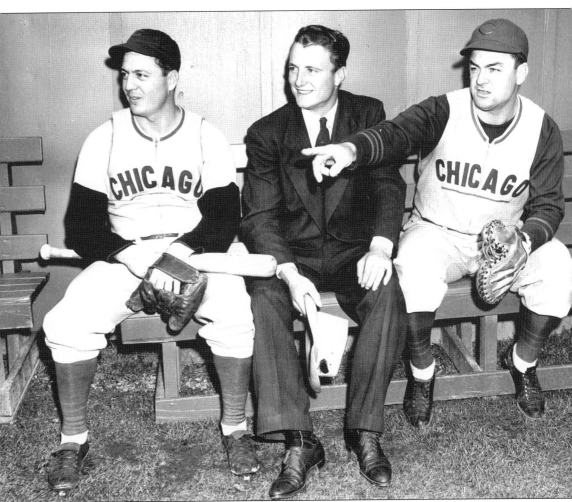

Seen at Catalina Island during spring training of 1941, from left to right, are Billy Herman, Lou Stringer, and manager Jimmy Wilson. Stringer became the Cubs' regular second baseman after Herman was traded to the Dodgers early in the season. During his reign as Cubs manager, from 1941 through early 1944, Wilson was not well liked by either the fans or his players.

Lou "The Mad Russian Novikoff" is seen at-bat during spring training on Catalina Island in 1941. Novikoff's Cubs career lasted from 1941 through 1944. In 1942, his only full season, he batted .300 but his fielding left something to be desired since he thought the Wrigley Field vines were poison ivy and refused to go beyond the warning track to catch a fly ball.

Cubs pitcher Dizzy Dean poses with movie actress Jane Frazee on Catalina Island in 1941. Dean was almost finished as a player and was appointed to Tulsa early in the season. Frazee, who acted primarily in "B" westerns, never attained genuine stardom.

Cubs pitcher Claude Passeau talks to manager Jimmy Wilson at spring training in 1941.

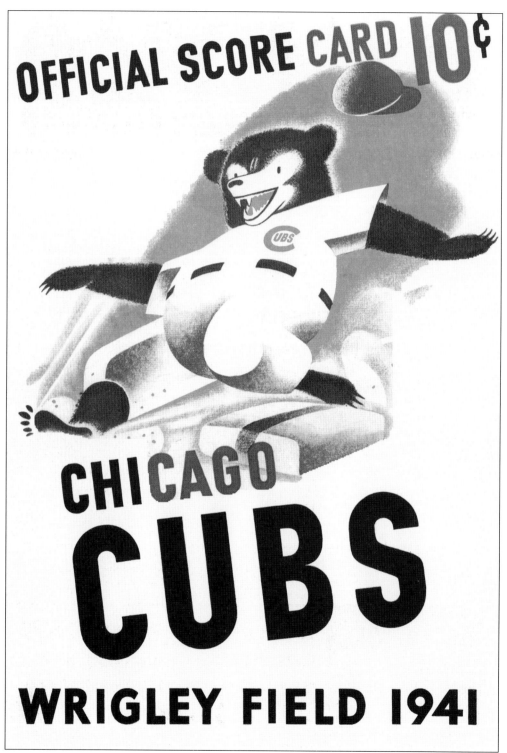

Still only 10¢, the 1941 game-day program and scorecard featured a more aggressive Cubs mascot on its front cover.

NATIONAL LEAGUE

Boston-P: 1-Posedel, 2-Salvo, 3-Errickson, 4-Sullivan, 5-Tobin, 6-Javery, 7-Earley, 8-Lamanna, 9-A. Johnson. C: 1-Berres, 2-Masi.

Brooklyn-P: 1-Wyatt, 2-Higbe, 3-Casey, 4-Fitzsimmons,5-Davis,6-Hamlin,7-Tamulis,8-M.Brown, 9-Wicker, 10-Swift, 11-Kimball. C: 1-Phelps, 2-Owen, 3-Guiliani.

Cin'nati-P: 1-Walters, 2-Derringer,3-Thompson,4-Turner,5-Beggs,6-Moore, 7 - Pearson, 8 - Vander Meer, 9-Logan, 10-E. Riddle, 11 - Hutchings, 12 - Guise. C: 1-Lombardi, 2-Baker, 3-West, 4-J.Riddle.

N.Y.-P: 1-Hubbell,2-Gumbert, 3-Schumacher, 4-C. Melton, 5-R. Bowman, 6-

Lohrman, 7-Wittig, 8-W. Brown, 9-P. Dean, 10-Adams, 11-Carpenter. C: 1-Danning, 2-O'Dea, 3-Hartnett.

Phila-P:1-Blanton,2-Beck, 3-Pearson, 4-Johnson, 5-Grissom, 6-Hoerst, 7-R.F. Melton, 8 - Bruner, 9-Crouch,10-Podgajny,11-Hughes. C: 1-Warren, 2-Livingston, 3-Millies.

Pit'burgh-P: 1-Klinger, 2-Heintzelman, 3-Butcher, 4 - Strincevich, 5 - Lanahan, 6 - Bauers, 7 - Lanning, 8 - Sewell, 9 - Joe Bowman, 10- Dietz, 11 - Wilkie, 12-Clemensen. C: 1 - Lopez, 2 - Davis, 3 - Schultz.

St. L.-P: 1-Warneke, 2-McGee, 3-M. Cooper, 4-Shoun, 5-Lanier, 6-Hutchinson,7-White, 8-Grodnicki, 9-Nahem, 10-Krist, 11-Gornicki. C: 1-Mancuso, 2 - Padgett, 3 - W. Cooper.

CHICAGO CUBS

	1	2	3	4	5	6	7	8	9	10	A.B.	R.	1B	S.H.	P.O.	A.	E.
6 HACK — Third Base																	
15 STRINGER — Second Base																	
31 DALLESSANDRO — Center Field																	
9 LEIBER — First Base																	
8 NICHOLSON — Right Field																	
19 NOVIKOFF — Left Field																	
21 McCULLOUGH — Catcher																	
5 MYERS — Short Stop																	
Pitcher																	

1 Wilson,Mgr.
2 Todd,C
7 Galan,OF
11 Lee,P
12 Hudson,IF
13 Passeau,P
14 French,P
16 Raffensberger,P
17 Root,P
22 Dean,P
23 Olsen,P
24 George,C
25 Mooty,P
27 Waitkus,IF
28 Sturgeon,IF

32 P. Erickson,P
33 Scheffing,C
40 Pressnell,P
41 Page,P
44 Cavarretta,OF
37 Spalding,Coach
38 Grimm,Coach

BOSTON

	1	2	3	4	5	6	7	8	9	10	A.B.	R.	1B	S.H.	P.O.	A.	E.
16 ROWELL — Second Base																	
9 COONEY — Center Field																	
8 MOORE — Right Field																	
4 WEST — Left Field																	
7 MILLER — Short Stop																	
5 DAHLGREN — First Base																	
1 SISTI — Third Base																	
11 BERRES — Catcher																	
Pitcher																	

2 Hassett,IF
6 Ross,OF
10 Masi,C
14 Majeski,IF
15 Wietelmann,IF
17 Posedel,P
18 Javery,P
19 R. Errickson,P
21 Sullivan,P
22 Tobin,P
23 Salvo,P
24 Lamanna,P
26 Earley,P
29 Johnson,P
34 Gremp,IF
35 Manno,OF
37 L.Waner,OF
32 Stengel,Mgr.
33 Kelly,Coach

UMPIRES

1-Reardon
2-Pinelli
3-Barr
4-Stewart
5-Sears
6-Magerkurth
7-Ballanfant
8-Goetz
9-Dunn
10-Jorda
11-Conlan
12-Barlick

See next page for the Official Wrigley Field Ground Rules.

AMERICAN LEAGUE

Boston-P: 1-Grove, 2-Wilson, 3-Dickman, 4-Dobson, 5-M.Harris, 6-Ryba, 7-E. Johnson, 8-Hash, Fleming, 10-Wagner, 11-Newsome, 12-Judd. C: Pytlak, 2-Peacock.

Chi-P: 1-T. Lyons, 2-Diedrich, 3-Lee, 4-Rigney, E. Smith, 6-Appleton, Haynes, 8-O. Grove, Humphries, 10 - Jorgens, 11-Ross, 12-Hallett. C: Tresh, 2-Geo. Dickey, Turner.

Cleve-P: 1-Feller, 2-Milnar, 3-Al. Smith, 4-Harder, 5-Bagby, 6-Andrews 7 - Eisenstat, 8 - Heving, 9-Brown, 10-Dorsett, 11-Jungels. C: 1-Hemsley, 2-Desautels.

Detroit-P: 1-Newsom, Bridges, 3-Rowe, 4-Newhouser, 5 - McKain, 6- Trout,7-Benton,8-Gorsica, 9-Giebell, 10-Thomas. C: 1-Tebbetts, 2-Sullivan.

N. Y.-P: 1-Ruffing, 2-Russo, 3-Bonham, 4-Gomez, 5-Donald, 6-Chandler, Murphy, 8-Stanceau, Branch, 10 - Breuer, 11-Peek, 12-Washburn. C: 1 - Dickey, 2 - Rosar, Silvestri.

Phila-P: 1-Babich, 2-A. Dean, 3-Beckman, 4-Porter, 5-Hadley, 6-Knott, Besse, 8-R. Johnson, L. Harris, 10-McCrabb 11-Marchildon, 12-Fenrick. C: 1 - Hayes, Brucker, 3 - Wagner, Leovich.

St. L.-P: 1-Auker, 2-Kennedy, 3-R. Harris, 4-Allen, 5-Niggeling, 6-Ostermueller, 7 - Caster, Galehouse, 9-Bildilli, Kramer, 11-Muncrief, Trotter, 13-Newlin. C: Swift, 2-Grace, 3-Grube.

Wash.-P: 1- Hudson, Leonard, 3-Chase, 4-Carrasquel, 5-Masterson, James Dean, 7-MacFadden, 8-Sundra, 9-Anderson, 10-Brashier, 11-Zuber, 12-Zuber. C: 1-Ferrell, 2-Earley, 3-Evans.

Since it still featured the home and visiting team lineup, the rosters for all National League and American League ball clubs, along with concession stand prices and ads from sponsors, the scorecard itself was little-changed from those of the previous decade.

Wrigley Field Offers You Thrills and Healthful Recreation

Wrigley Field is especially designed for you and your family. Every care been taken to make it a place where you really enjoy yourself—forget cares—have a good time at small cost in the healthful out-of-doors.

Your convenience and comfort always come first. Attractive restaurants—comfortable seats — modern bleachers — convenient restrooms have been added to make your afternoons "watching your Cubs play ball" more fun.

Today Wrigley Field is famous as "America's finest recreation center" both for the teams and for the loyal fans who support them.

In the field today are 38,396 seats, laid out as follows: 19,357 grandstand seats (13,726 in the lower deck and 5,611 in the upper); 14,059 box seats (8,949 in the lower and 5,110 in the upper), and 5,000 roomy bleacher seats.

By the summer of 1941, Wrigley Field's amenities were being highlighted in the daily programs that Cubs fans could collect at the ballpark. Now several pages long, sponsors submitted more colorful advertisements and the Cubs organization used the programs as a vehicle for self promotion.

Pint-sized (five foot, six inch) Dom Dallessandro was a Cubs outfielder from 1940 through 1947, with time out for military service in 1945. Although he batted .305 in 1944, "Dim Dom" is best remembered for getting his foot stuck in the Wrigley Field vines while attempting to make a leaping catch in a 1946 game.

Lennie Merullo, Cubs shortstop from 1941 through 1947, probably would not have lasted that long in the majors had it not been for World War II. Although Merullo had good range, he also tended to be erratic and was not much of a hitter, batting .240 lifetime. He later served as a scout and was responsible for the Cubs signing pitcher Moe Drabowsky and second baseman Glenn Beckert.

Hiram Bithorn came up to the Cubs as a rookie in 1942 and enjoyed an excellent season the following year, going 18-12 with a league-leading seven shutouts and a 2.60 ERA. After two years in military service, Bithorn was overweight and out of shape when he returned to the Cubs in 1946. He won only six games, appeared in one for the White Sox in 1947, and then vanished from the majors.

A happy-looking Lou Novikoff grins for the camera in 1942. His defensive ability, however, was nothing to smile about.

The above *c.* 1944 snapshots capture three of the best wartime-era Cubs. From left to right are Andy Pafko, Phil Cavaretta, and Don Johnso. Cavarretta rarely smiled for the camera, and this occasion was no exception. A youthful Andy Pafko—"Handy Andy"—was one of the few members of the 1945 flag winners to perform consistently well against post-war competition. A fine defensive center fielder with a strong throwing arm, he batted .302 in 1947, .312 in 1948, and .304 in 1950. On June 15, 1951, Pafko was swapped to the Dodgers in a trade that rivals the Billy Herman deal in Cubs front-office ineptitude. He helped Brooklyn win the 1952 pennant and then finished his career with the Milwaukee Braves, retiring in 1959 as a .285 career batter with 1,796 hits and 213 home runs. As a second baseman, Johnson had two good years as a Cub in 1944 and 1945, batting .278 and .302, but the best he could muster after the war was a rather timid .259 in 1947. He was released in May 1948, a lifetime .273 batter with 528 hits.

"Order another cold one" seems to be the antidote to post-season blues for generations of Chicago Cubs fans.